Aspects of Art Work with 5- 9-year-olds

Aspects of Art Work
with 5- 9-year-olds

by Sybil Marshall, M.A.
Senior Lecturer in the School of Education,
University of Sussex

Published by Evans Brothers Limited
Montague House, Russell Square, London W.C.1

Printed in the Republic of Ireland by Hely Thom Ltd., Dublin

237 28047 7 PR 4415

Contents

Acknowledgements

This book is based on a series of articles which first appeared in *Child Education*.

The examples of children's work have been collected from a large number of schools by the author.

The author and publishers are grateful to Cambridge University Press for permission to reproduce Figures 1 and 4, which appeared in *An Experiment in Education*, by Sybil Marshall.

1 Beginning at the beginning

THIS book is intended to deal with as many aspects of art work as possible with children between the ages of five and nine.

A good deal of nonsense is still talked about 'child art', though mostly by those who do not understand it and have no means of judging it either in its own right as 'art', or as the result of child activity with art materials. There may be those who can honestly see a great deal of beauty of line, colour, composition and so on in a picture done by a child—I can myself, sometimes; but not every picture produced by a child is beautiful, nor are all the pictures done by one child, however accomplished a little artist *(sic)* he may be. Assessment depends on whether you are judging the work itself, or the work in relation to the child, or the work in relation to such work as can reasonably be expected from children in general in the same age and ability group. Teachers in particular are not usually concerned with the merits of the end products of an art lesson, or an activity period, as 'art': they are concerned with the children who produce the work, and the part such art experience plays in the development of the whole child. So we would agree that the main purpose of art in the Primary School is not to produce pictures (or any other form of visual art) by a few gifted children in order to win prizes at an exhibition, or even to decorate the walls of the school on open day; but it is to aid the over-all development of children. As art should be one of the cornerstones in the structure of the children's entire education, let us begin right at the very beginning.

Experience precedes understanding

What does a child at the Nursery School, or even at Infant School reception stage, make of activity connected with art? To answer this, we must consider the child

(a) in relation to the materials set before him, and

(b) in relation to his understanding of pictures in general.

Some children will have had experience of both in their pre-school days, either at home or in a play group. Many more will have had little or no experience of either. We cannot take it for granted that children understand pictures, whether in simple line, colour, or in photographic form. It is true that such understanding comes early, but it is not born with children and, like language or anything else, it grows in proportion to the child's experience of it, and to the stimulus offered. The television set is not necessarily an aid to this understanding because on the T.V. screen the pictures move, and therefore become self-explanatory, the movement being read instead of the image. In my opinion, familiarity with a T.V. screen may, in fact, delay understanding of a 'still' picture.

Then again, pictures for children are produced by adults who have wide and varied experience, but the child's experience is in comparison small and limited. Moreover, the child may simply not see in a picture what an adult knows is there.

Lastly, a child may have to learn, in school, the fundamental fact that it is possible to represent his environment by means of pattern-symbols on paper, and in any case, in order to recognise and translate such symbols, he must have some previous experience of what they represent.

Now let us return to the 'art' or 'activity' period. With easel, paper, paint, water and brush set out before him, a child, already overwhelmed by the new experience of school as a whole, is more often than not invited by the teacher to 'paint me a picture'. Unless he has already reached the stage at which he can 'read' pictures easily for himself, one might just as well ask him to recite a few verses from Isaiah, or perform the Indian rope trick. We know what happens. Those who can already,

do it with confidence, and an honest desire to please the teacher. Those who do not understand what is being asked hang back or refuse with a shy shake of the head, and either stand wistfully watching or else seek safety somewhere else in the room with play they do understand. So please let us agree to remove the word 'picture' from the context of art activity in the very early stages of Infant work. The best context for the picture, and the best aid to art in the long run, is the carefully selected, sensibly illustrated, imaginative picture/story book. That leaves us with the paint, which is quite a different matter.

Early explorations

To the small child, everything exists to be explored, experimented with, tested, assessed, remembered and, thereby, learnt. In water play, he learns the properties of water; in sand play, of sand. When he mixes them, he learns that they affect each other. He cannot make a sand pie that will stand up firmly until he has learnt exactly how wet to make the sand. If such play has an object that can be isolated from its all-round importance as play, that object is certainly not that every child should be able to make firm sand pies. It is that he should discover for himself and assimilate the knowledge of his environment, and his enjoyment in so doing is atavistic.

So with paint, or crayon, or indeed any object that will make a mark on a plain surface. Why did our remote ancestors first scratch pictures on the walls of their caves? To 'make hunting magic'? I don't believe it! *They did it because they found out that they could*—and that was magic in itself. I do not doubt that they put this magic to good use in hunting afterwards; but who am I to contradict learned and scholarly authority on this matter? All art is magic, and sooner or later we all put it to good use. A plain surface invites change. It demands interaction between itself and some other substance with the property of marking it, and so of re-arranging the pattern of experience. Lavatory walls, church windowsills and the backs of dusty buses all bear witness to this fact. Which of you can resist

writing your name, or drawing a face, on a steamed-up window?

All children love making marks on a plain surface, as house-proud mothers know to their chagrin! The teacher provides the surface in the form of cheap, expendable paper. If paint is the medium set before the child, then there is added enjoyment, for it provides colour and other opportunities for experiment. It can be mixed thin or thick, very wet or fairly dry, slippery or sticky on the brush. There is no end to the things you can try out with this exciting coloured dust. Then there is the brush: it will make big splodges of colour, or thin lines, or fat spots and dabs. When you have learned to control it, it will go round and round in a spiral (quite often the first deliberate movement), or across the page in a straight line, or down the page in a 'wiggle' or a 'zigzag'. As you get more used to it, you can actually turn it, and go across the page and then down, changing direction without lifting it from the paper, and so on.

Very often these early experiments are termed 'pictures', though more often they are referred to as 'patterns', which is, I suppose, nearer the mark; but a child is not going to learn the true meaning of either word by its misapplication at this stage.

I was in the reception class at an Infant School when Fig. 2 was produced by a child not quite five years old. His young, attractive teacher and I had watched him trying out his paint and his brush, and we shared his delight at his achievement. Then she made a mistake. She wanted him to 'verbalise' (Ugh!).

'What have you been painting, John?' she asked. He did not reply. She squatted down and touched him, thereby distracting him and spoiling his concentration.

'What is it, John? What is it a picture of?' The child grew more and more anxious as she continued to question him, looked at her, at me, and all around him, seeking inspiration. He was obviously a bright boy who knew already that pictures were 'of things'. The trouble was that he hadn't been making a picture. However, he had somehow to satisfy the demand being made upon him and in a kind of desperation he said 'It's a bird on its nest', (there was a nature table with an empty bird's nest

upon it almost at his elbow). The teacher was satisfied, and I was sad. What good had this done to his verbal ability? What harm had it done to his enjoyment and exploration of paint?

The time will come, of course, and very quickly too, either by means of understanding what pictures truly are, or by the immediate recognition of a shape produced by chance, when every child will make pictures to which he can set a title. It depends upon his experience, both of paint and of his environment.

The four-year-old boy who painted Fig. 1 did so by chance. He rushed across the room to me, pulling me by my skirt towards his work, repeating as we went, 'Look! Look! I've drawed a tree! I've drawed a tree!'

The picture was published in my book.* A teacher friend from the Scottish Highlands showed it to his own four-year-old daughter. 'What is it?' he asked. Without a moment's hesitation, she replied, 'It's a deer coming through the mist!'

When children reach this point, the first exploratory stage is over, and it is then up to the teacher to help them organise both their ideas and their materials, and picture- and pattern-making can truly begin.

*An Experiment in Education
(Cambridge University Press).

2 The choice and care of materials

One cannot make omelettes without first breaking eggs. The eggs I am referring to are the methods and practices which go on in school from year to year, and from decade to decade, for no better reason than those often given to me by teachers: (a) 'We have always done it like this'; (b) 'I never gave it a thought!'; (c) 'We've got these, and the head says we must use them!' In the field of education this attitude simply will not do. We have to go on examining our methods and our ways of doing things with a very critical eye, asking ourselves all the time if there is a better way – one that will help the children achieve better results or that will save them (and us) fatigue or frustration. In no area of Infant School activity is the need for constant re-thinking more evident than in work connected with art, but before we proceed, may I make it quite clear that I am perfectly well aware how limited funds usually are, and that I am not making a plea that every new medium or gadget that appears on the educational suppliers' lists should immediately be tried out.

A survey of materials

When 'child art', or 'new art' (as it was often called), crept into our schools some forty years ago it replaced, for the boys at any rate, a lesson called 'drawing', which was done on cartridge paper with a 'black-lead' pencil. For the girls, it was a complete innovation in many cases, as they had usually been sewing while the boys did drawing.

Now cartridge paper is expensive, and H.B. pencils break easily under the pressure of small, tensed hands. Moreover, the results, in most cases, were not what one could call encouraging. The great breakthrough was made by substituting a fat brush for the fine pencil, and powder tempera for the black line. Both these demanded larger sheets of paper than those in the 11 in. by 7 in. drawing books, but obviously the larger sheets could not be of expensive cartridge paper. In the search for a cheap substitute, the soft white paper used in shops for wrapping and at home for lining shelves, etc., came into its own. Manufacturers were quick to see the possibilities, and 'kitchen paper' was added to every supplier's list, along with 'hog brushes' and 'powder paint'. Very soon, the soft blue paper of which sugar bags used to be made joined them, and very good they all proved. So, after thirty years or more, one can still go into many schools and see children whose ages range from five to eleven all equipped identically for painting with

(a) a double easel, slanting away from the child and with a narrow ledge at the bottom on which stand two or three jars of ready mixed paint;

(b) a jam jar of water, usually placed on the floor and precariously near the child's feet;

(c) an object which once was a hog brush, but is now a dirty, twisted stick with a rusty, loose tin ferrule from which protrude a few stiff bristles;

(d) an oblong of white kitchen paper, about 12 in. by 20 in., frequently pegged to the top of the easel with plastic clothes pegs. If the paint is given to the children in its dry form, a six, nine or twelve hole bun tin is generally used for the paint.

Suggestions for the use of kitchen paper

The first egg I want to smash is this formula for Primary School (especially Infant School) painting. As I have said, I have nothing against kitchen paper. It is invaluable in school, and I just do not know what we should do without it; but it

need not be so relentlessly uniform in size and shape, nor so prosaically dull and unexciting by being the same from day to day and week to week. Kitchen paper came into our classrooms because it was cheap, and it remains there for the same reason. There really is no need to be niggardly with it—or with sugar paper either, though that is a little more expensive. Is it really necessary to slit every sheet into four equal rectangles? If the Head has decreed that one sheet of paper must serve four children then a little mathematical ingenuity could still ensure difference in shapes and size. The easel is usually square. Why should not the piece of paper on it sometimes be square too? The bits that have to be cut from the rectangles of kitchen paper to turn them into squares have dozens of uses, and the children will be quick to find them. I have seen them used

(a) for making little books in which to write a 'free' story;

(b) lists of prices in the shop;

(c) record cards in the dolls' clinic;

(d) recipe cards in the cooking corner;

(e) kings' crowns or Red Indian headdresses—and so on.

In fact, they may be just what is needed to spark off a bit of valuable, imaginative dramatic play. The teacher should experiment, as well as the child.

The use of easels

Next, do you know how difficult it is to control the sort of mark you want to make on paper held insecurely to the easel by a clothes peg? If you mix your paint thinly, it runs all down the paper and spoils it. If you make it thick and sticky, then the paper, loose at the bottom, sticks to the brush and moves with it. An upward movement rucks the paper up, a downward one pulls it from under the peg, or down altogether. If kitchen paper, which is thin and flimsy, must be used, then some way simply must be found of fixing it firmly to the easel. Metal

clips made expressly for the purpose cost approximately 3d. each from any artists' supplier. The easels are usually made of such intractable board as to defeat all efforts to put a drawing pin in at the bottom of the paper, but a tiny scrap of Sellotape will suffice as there is no weight there.

Sugar paper is much stiffer and firmer than kitchen paper, and may not need securing at the lower corners. It also has the advantage that it nowadays comes in different colours. I am always being asked why a coloured paper is 'better' than a white one. Well, it isn't always better, of course. Colours show up excellently on white paper, but the colour of the background does have a modifying effect on all other paint put upon it. A coloured background paper therefore provides an entirely new field for exploration and experiment.

Paints and containers

This brings us back to the paint. It is sad to see children having to use paint mixed ready for them, even if there is a good range of colours to choose from. They are deprived of essential practice in getting the paint to the consistency required for the job in hand. This applies, in a lesser degree, to the solid tempera-block type of paint as well. In whatever way the children are given the paint, however, some sort of a flat palette on which to mix the colours is an absolute necessity. As this must be held in the hand, it must be reasonably light in weight. Plastic tea plates are good because, apart from lightness, they have the advantage of being easy to wash and do not rust as do baking tins, which are often used for this purpose.

Dry paint is most usually given in bun tins, but these are by no means ideal. They are too shallow, too large in area, and difficult to store because they will not stack with paint in them. Several firms have good containers on the market, usually in plastic, but they tend to be expensive and again are awkward to store. The very best containers I have ever found are the plastic trays intended for making ice cubes. The wells in these are deep and divided from each other by a little

ridge, which means that the dry powder does not spill over from one to the next. This depth also enables them to be stacked one on top of the other so that the paint in the lower one is not touched. There are twelve compartments in them as a rule, which is too many, but even this has the advantage of leaving one end empty and clean for handling and holding. Five colours are, of course, essential; these are the three primary colours and black and white. With these to mix the children can get a fair range of colour, but they are not truly adequate. Which red will you choose, for instance? The bright, clear, vermilion-type red will not make a good purple, so a crimson must be added. Green can be made from yellow and blue, but viridian added to the palette makes an exciting addition—so does burnt umber. My ideal palette for young children consists of nine colours: vermilion, cobalt, mid-chrome, crimson, viridian, burnt umber, black and white, with a choice of burnt sienna, prussian blue or yellow ochre for the ninth. Incidentally, the children should be encouraged to use the correct names for the shades chosen. They shouldn't just say 'red' or 'green', but 'vermilion' or 'viridian'. Such unusual words have a fascination for young children anyway, and they are bound to meet them in stories before long.

The care of brushes

Brushes are tools, and must be treated with respect. They must also be good tools if they are to do their work well. It is a mistake to buy cheap ones on the principle that anything is good enough for young children to spoil. Paint brushes are expensive, especially the good quality ones, but it pays in the long run to get good ones. Children should be taught how to use them carefully. They should never be left standing on their bristles in water, even for a few minutes. They should be laid flat until they can be washed properly and afterwards dried well and the bristles smoothed back into shape. They should be stored with the handle end in a container wide enough at the mouth to allow air to circulate in between them. A supply of rag to dry them on is essential—but small pieces of rag are essential in a painting session anyway, and each child should

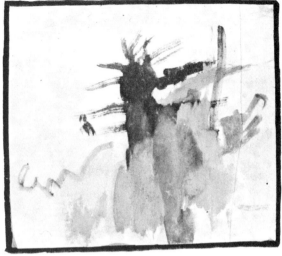

Fig. 1. 'I've drawed a tree': a four-year-old's description of his painting

Fig. 2. The painting of a boy of four-plus years

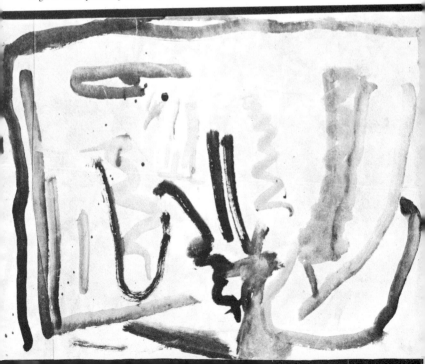

Fig. 3. A painting by a child of three

Fig. 4. Another painting by the same child, when aged three-and-a-half

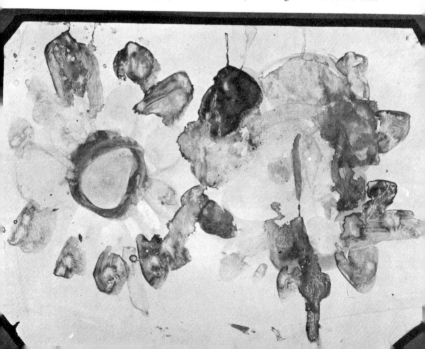

have a piece to hold in his hand while painting. This saves a great deal of mess and frustration.

One cannot have any child activity without some mess, but the amount of mess can be reduced by careful planning and a bit of common sense. A jam jar, even a one pound size one, is much bigger than a child needs for painting. If a jam jar full of dirty water is tipped over, the resulting flood is almost a disaster. Two inches of water in a plastic cream or yoghourt container is quite enough; besides, these containers stack one inside the other and take hardly any room in storage.

I have tried to give a few very practical hints to make the painting session enjoyable, as well as profitable. My ways are not necessarily the best or the only ways, and any teacher may find new ones for herself.

In paying attention at such length to paint, I do not wish to imply that it is the only medium suitable for Primary School children. Obviously it is not, and I shall be dealing with other ways of making pictures later; but paint is the basis of art activities in the Primary School and it is well worth while to give careful thought to the way in which it is first offered to children.

3 Early progress

In the first chapter I stressed the need to allow the very youngest children to explore their materials and learn how to handle them, and to discover for themselves that these materials can be used to record environment by means of patterns and pictures. That chapter came to an end at the point at which the child had learned to organise his material and to control his tools, and had also begun to see his own environment as an organised pattern of existence.

'Organisation', then, sums up the first stage of development, and very often the first evidence that this is taking place is when the child begins to produce patterns which we recognise as such. Figs. 3 and 4 are by the same child, when aged 3 years and $3\frac{1}{2}$ years respectively. I do not think Fig. 4 was conceived as a 'picture' of two flowers. On the contrary, I am sure that it was merely an exercise in the controlled organisation of paint which, because of the pattern of its arrangement, suggests flowers to us.

The value of pattern-making

At this stage many children love 'making patterns' of any kind, and this enthusiasm should not be wasted. A little encouragement in doing the Marion Richardson type of pattern, based, as it is, on the natural movements of the child's hand, may not only give a great deal of enjoyment to the child in achieving something towards which he is already struggling, but also

prove a lasting asset to calligraphy, whatever style is eventually used. Once more, however, I feel that I must add a warning. Children will not go on producing this sort of pattern for very long unless there is some aim and purpose for it. The first one or two will be done for practice and for the fun of it, but after that they should be put to use somehow or other: as book covers for the children's scrap or story books and diaries, for example, or as frames for the classroom's flower decoration, as wallpaper for the Wendy house, or incorporated into the classroom display—and so on; they should also be changed constantly so as to provide a reason for doing more and better ones.

Drawing pictures

Stage two is that of 'I've drawed a tree!' Again, there will be a desire on the child's part to practise a skill so newly acquired, and teachers may get a little bored with what seems like endless repetition of trees, houses, petrol pumps, or whatever it may be. There is no need to worry unless the repetition goes on for an unduly long time. If the growth *into* this stage has been a natural one, then the growth out of it will probably be just as natural. Danger lies in a situation, however, when the teacher, or any other well-meaning adult, has shown the child 'how' to draw an object. The child copies the adult symbol for the object without understanding it. He is then probably congratulated on his work by other adults who do not know how it happened and do not understand the characteristics of children's work, but think it 'good' because they react to the pseudo-adult picture. Then, after this, the poor unfortunate little artist is in the same predicament as the miller's daughter on the morning after Rumpelstiltskin's first visit. Instead of being satisfied, the greedy king asked for more and more straw to be spun into gold, so she was asked to repeat in a bigger and better way what she had no idea how to accomplish unaided in the first instance. With the child and his 'drawing', we all know what happens. In order to avoid trouble, he falls back again and again on his previous 'success', and repeats the same thing *ad nauseam*.

Attempts at figure drawing

If development continues naturally, it will not be long before the child attempts figure drawing. This is an exciting phase, and is manifested by all sorts of strange arrangements of shapes as well as those we can recognise as 'people'! Sometimes children draw only heads with great round eyes and gaping mouths, like mangold-wurzel masks; sometimes it is merely a round shape with an unspecified number of darker dots in it. Very often the round head will be flanked by two uprights representing the legs, or these may be under the head but detached from it. When, finally, the pieces come together into something recognisable as 'a man', arms usually protrude from the side of the head, and legs from under the chin. The trunk is more often than not omitted altogether. It is interesting to speculate why this should be so. Is it because he is not aware of the trunk—his own or those of others, or because he simply does not know how to 'draw' it? My own view is that he puts on the paper what he 'knows', but what he knows is conditioned by his experience and his views of things. We must understand that the child's eye-view of the world is not quite the same as our own. He must, for one thing, spend a great deal of his time in a world made up chiefly of adult legs, like Gulliver among the Brobdingnagians. Then, hands are always doing things for him, arms holding him, and faces smiling or shouting at him.

A friend of mine had a splendid piece of direct evidence on this point handed to him by a very small boy. The little boy volunteered to draw a picture of himself accompanying his mother to the January sales. This depicted the normal figure drawn by a four-year-old, accompanied by a smaller one of the same variety; and every other available inch of space on the paper was filled by objects the same shape as a golf club.

Puzzled, my friend (an art organiser from Canada), asked the child to explain. In one word, and with utter scorn of his adult ignorance, the child answered him—'feet'.

The picture shown at Fig. 6 is by a four-year-old girl, and is called 'Me and my mum in the garden'. In these figures

the trunk is there. Notice what bold, big figures they are, and how well they fill the paper. The little girl is ready for this stage of her own development. She has not been pushed forward too quickly: it was her idea to paint this picture, and she was confident that she could do it.

Further developments

Progress may now begin to speed up. Fig. 5 is the work of a five-year-old boy, painting a vase of flowers. It covers a sheet of cover paper, 30 in. by 24 in. Each flower is seen as an organised pattern of shape and colour in its own right, but the whole composition is also envisaged as a pattern of shapes and colours related to the shape, size and colour of the background.

Stories begin to link up with painting in two ways. When a child has heard a story, or played through a story situation in some piece of spontaneous dramatic play, he may want to savour it all over again through some other medium, and paint himself back into it; on the other hand, he may quite well make up a story for himself, painting as he goes and at the same time recording it to himself in a monologue. 'This is a wood and there's a little hut in it, and an old witch lives in the hut and you can't see her because she's gone out and so has her cat and this is me coming into the wood and if the witch comes home I shall frighten her away—' and so on (Fig. 7).

The role of the teacher

Growing observation, growing powers of imagination, accumulation of experience (both concrete and imaginative), development of manual control, assimilated knowledge of techniques—all combine to help the child achieve, and with the satisfaction of achievement come the desire to attempt still more and the confidence to begin. As the bounds of ambition are set wider and wider, the teacher must be aware of what is happening, and ready, always, to offer advice when it is sought and help when it is needed. Most of all, perhaps, she must be able to assess the finished work and comment on it fairly and con-

structively. This is a difficult task because children are quick to detect the note of insincerity, and soon distrust the inevitable comment of 'Very nice, dear', or the gushing verbal pat on the back, 'Darling, it's *lovely*. What is it?' Nevertheless, a word of praise is essential—and, whatever you do, don't ever let a child see you putting his picture in the waste-paper basket.

The teacher has another duty, too. Left to himself, every child would undoubtedly develop to some extent at his own rate, but the pace of some children would be very slow indeed. Moreover, all his process of development must depend on his experience, and the teacher's duty, beyond all else, is to feed experience to him, subtly and unobtrusively and without detracting from his enjoyment as he learns. It will enter through his eyes, ears, nose, tongue and finger tips; and to the lively teacher, there are as many ways of putting experience before the children as there are ways in which the children will use it.

4 Media other than paint

Though, as we have seen, paint is the best medium with which children can begin their art experience, it is by no means the only one. Here we must make a division between materials with which to make pictures, and other ways of providing experience of the kind that will engender artistic growth. As we have been talking in terms of paint until now, it would perhaps be wise to continue first with the other ways of making pictures.

The use of crayons

After paint, the next most obvious choice of medium is the wax crayon. There are fat crayons, thin crayons, pencil crayons; there are those that are so soft that they bend in a warm hand, and those that are so gritty that they scratch the paper and set one's teeth on edge into the bargain. With regard to the quality of the crayon, every teacher must discover for himself the best he can screw out of his budget allowance. Firms are usually willing to supply samples, which should be put through a test for quality in use, not merely accepted as a bonus to the art cupboard. I always deliberately break the crayon in the middle, and try all four ends for smoothness and covering power. I hold another one in my hand a few minutes before using it, to see if it becomes oily or so soft that it bends when put to paper. For coverage I lay the crayon on its side, and try both light and heavy pressure; and of course, some colours are much

better than others. They vary a little in price, but the best quality is usually the cheapest in the long run.

With the other type of crayon I find it easier to deal. I hope I shall not shock too many of my colleagues by stating flatly that I loathe pencil crayons, and that if I could have my way I would throw every one of them out of the Infant School— and even out of the Junior School too. I know that children like them *(faute de mieux*, perhaps?); that they are clean and do not make a mess; and that they are easier to keep in the children's desks, bags or boxes. The trouble with them is that they are mere 'colourisers', that is, they merely colour in shapes made by lines. They do not lend themselves to producing anything but colour, being too fine to produce mass of any size at all, and they will not mark well over each other, failing thereby to give any variation in tone or texture. In fact, as an art medium, they have no individual character. Furthermore, they require constant sharpening and are therefore un-economical in use. Many of my friends who are teachers of Juniors tell me that they could not manage without pencil crayons, and aver that for illustration of history, geography and science, they could not get on without them. They show me work of meticulous neatness in which the outline is drawn in pencil, perhaps inked over, and the drawing then coloured with pencil crayon. Obviously, if any teacher thinks sincerely that such illustration is an aid to the subject he is teaching he would be very foolish to give it up. Do not let us, however, confuse this with art.

The value of pencil drawing

Now the pencil itself is another matter entirely. It is, in my opinion, a fallacy to think that all children love to paint in big, bright mass, or that they want to do this to the exclusion of all other ways of producing a picture. Many little children delight in line drawing (as the backs of buses show us, again). Some, given the biggest brushes and the largest sheets of paper, will still only draw shapes in outline. Moreover, given absolute freedom to choose materials for themselves, they may

surprise one by the small size of paper they take, and by choosing an ordinary lead pencil as their tool. I find this frowned upon for some reason by many teachers, as if it is not quite respectable—but of course it is a delightful way of making pictures and should be encouraged, provided that the pencil is designed for the job. A hard, pin-pointed pencil is obviously unsuitable. The pencil should be black and reasonably soft, capable of making thin lines as well as thick ones, and of filling in bits here and there quickly if the child so desires. For my own part, I prefer the flat, square type, like a carpenter's pencil. The variety of line one can get with these is greater, and they require sharpening less frequently. If one wishes to teach Italic writing at this or any later stage, they have an added advantage in that they provide splendid practice in handling the right sort of tool.

Fig. 8 is by a boy of six using one of these pencils. It is his impression of the Israelites crossing the Red Sea. The lines are firm, distinct and confident. As illustration, this picture is easy to comprehend in this medium, but I think the subject would have been well beyond the scope of a child of this age using paint and a thick brush.

Activities with pen and ink

While on the subject of line drawing, let us consider the other tool available to us in school—the pen. As writing tools, pens have gone out of the Infant Schools, and most of us are grateful for this mercy. They do reappear in the Junior School, and most children are expected to learn to use one before leaving. What sort of writing will be taught, and what kind of pen will be acceptable for it, depends upon the teacher. It may be that before long we shall have to decide whether we wish to preserve calligraphy as a necessary skill, or merely to be content to regard it as an obsolete art form, because the ubiquitous ball-point and the typewriter have reduced the possibility, as well as the necessity, for 'a good hand'. But, whatever we decide with regard to handwriting, as a tool for drawing, the pen still has a function in our schools. Small children delight in using pen and ink and, in my experience, very rarely make a mess

with it when drawing. I suggest that in the Infant School the ink should be of the blue-black washable sort, but the true, black, permanent kind should be safe enough at the top of the Junior School. If a metal pen is to be used, the paper should have a smooth surface. (Practice lettering paper is ideal for this.) For felt pens, sugar paper is quite adequate. Both metal and felt pens come in a variety of sizes, from the ordinary writing nib to the lettering pen half an inch across.

With pen and ink the attack must be bold and confident for, once a line is there, it cannot be rubbed or washed out. I am always surprised how bold children can be, and with what ingenuity they mask or incorporate a line that 'went wrong'. Very often such a line actually adds something to the result.

Fig. 9, 'The Annunciation', is by a boy of six using an ordinary medium/fine writing nib. The angel here is touched delicately with yellow wax crayon and with gold ink. (Gold in any form is a powerful incentive!)

Fig. 10 is by a six-year-old girl, using her ordinary pen nib and black ink. It is part of a whole book made co-operatively by the entire class, each child taking a phrase and illustrating it pictorially in whatever medium he chose.

The book contains the lovely Psalm 148, in which all things are exhorted to 'Praise the Lord'.

> Mountains, and all hills;
> > fruitful trees, and all cedars:
> *Beasts, and all cattle;*
> > creeping things, and flying fowl.

Notice the freedom of the pen-lines in the mane of the lion, the confidence with which the cow's head has been drawn, and the complete nonchalance with which a tiny creature that 'went wrong' has been ignored, and the fact that it now shows through the side of the donkey disregarded. Notice also the many touches of humour in this picture—the mice playing round the feet of the giraffe, and the curl on the tails of the baby pigs, for instance. This is a sure sign that the young artist is not finding the medium in which she is working a difficult one.

I wish I could show, as another example, a page from a

similar book, of Psalm 104, but the drawing is too delicate for the reproduction to be satisfactory. This is a panel, 15 in. by 11 in., representing the phrase 'Where the birds make their nests', drawn by a girl of seven. It is entirely covered by a spreading branch of a tree, with every tiny twig and leaf drawn meticulously in ink; between them and around them and on them are a multitude of birds, with a few nests interspersed. Then, every tiny leaf, nest and bird is decorated with fine patterns, the effect of these being considerably enhanced by the variety of nib sizes employed. The whole panel is a mass of subtle colour, for every drawn and decorated shape was then washed over with diluted coloured ink, mixed by the little artist till she had invented shades unknown to the makers of the inks; and again, she added an extra touch by reinforcing the patterns with others in the pure colour of the ink, just as it came out of the bottle. Gold used sparingly was the final touch; and the whole effect is one of medieval magnificence. The picture took a long time to finish, but never once did the child falter in her determination to complete the task she had set herself.

The use of outlines

In such pen-and-wash drawings, the line is a legitimate part of the picture, a co-equal partner with the colour; the picture is not merely a colour-filled outline. A pencilled outline, afterwards filled in with colour, is not the same thing: the pencil cannot hold its own against the colour and adds nothing to the finished work. If paint or wax crayon is going to be used, especially on a large sheet of paper, pencil outlines should not be allowed. Of course the children may want to make a sketch of what they propose to put in their picture; with paint this can be done adequately with nothing more than a wet brush If for any reason, such as the knowledge that a picture may take two or three sessions to complete, a permanent outline needs to be fixed, then chalk is the answer. It is soft, will rub out easily, and does not dirty the paint applied later, as charcoal used inexpertly tends to do. If crayon is to be used, the faintly

drawn outline of a neutral-coloured crayon can be covered up by the thicker layers subsequently applied. But there is much to be said about using wax crayons.

5 Making the most of wax crayons

Very rarely does one see a picture executed by a child in wax crayon to which one could unhesitatingly apply the adjective 'satisfying'. Many pictures may be lively and include most of the qualities we have come to look for in a good piece of child art, but one is conscious that, compared with a picture in paint, the wax crayon picture seems to lack something. I suggest that what it lacks is strength, and, if this is the case, there is no reason at all why this state of affairs should continue. Unless one knew how to get the best out of paint and a brush, one would not get the best; it is exactly the same with wax crayons. One must give them a proper chance by discovering and making the most of their potentialities. After all, if to an adult looking on, so to speak, the picture is not satisfying, then the chances are that the child who did it is also a little frustrated, and it is perhaps time to remind ourselves that it is the child, and not the picture, that really matters.

The use of new crayons

When wax crayons are brand new they are usually (though not always) wrapped round with paper which leaves only a carefully tapered point of wax actually showing. I suppose the paper is an attempt by the manufacturer to minimise the effect of the child's hot hand upon the wax, and I know that many children dislike the feel of the wax in their fingers

and are grateful for the paper. But the fact remains that the form of the crayon, when new, presents the child with a limited view of its possibilities, because it too much resembles the pencil, of which the sharpened point only is intended for use. The result is that wax crayons are often used like pencils; the children regard them as line-drawing tools, rather than tools for producing brilliant colour in mass.

After a few minutes' use, the fine point is worn down to a blunt, rounded end; and after a few days, the wax has worn down to the paper, which must then be torn away to reveal an even broader, blunter end. The children then become disappointed and frustrated because the fine lines are no longer so easy to make—I have actually caught little boys sharpening away expensive crayon surreptitiously with their pocket knives, in an attempt to restore the tapering point. In the space of a few weeks, the 'new' crayons have become a jumble of wrapperless short pieces and, unless encouragement is given, interest in them dies away and they are left in the cupboard unheeded. But it is when they reach this stage that they can begin to be really useful and exciting.

Variety of effects

The depth of colour obtained with a crayon depends upon the pressure put on it. This means that there is an almost unlimited range of effects possible with only one crayon, according to the way it is held, in which direction, i.e. horizontally, vertically, obliquely, spirally, etc. it is used, and above all how hard it is pressed. The result also depends to some extent upon the kind of surface the paper has; a smooth-surfaced paper helps the wax to retain its polished, shiny effect, while a rougher surface will produce a less glossy but more textured appearance. Broad areas of rich colour can be laid by using the side of the crayon and pressing hard; delicately tinted backgrounds can be obtained by using the side of the crayon so lightly that it barely touches the paper. Once the children realise that the crayons are not 'spoilt' when broken, and that one can do all sorts of things with them other than drawing

in line, they will begin to experiment with them as constructively as they do with paint.

Fig. 11, which is 22 in. by 32 in. actual size, is called 'Angry Witch', and was executed entirely in wax crayon by a girl of seven. There was a large area to cover, so she concentrated on the important things and laid her crayon thickly there, but the background was only very lightly and quickly drawn in. Fig. 12 is about 20 in. by 18 in. in size, and portrays Daniel in the lions' den, the artist in this case being a girl of eight. Here the effect of the crayoned lions is heightened by the contrast of an angel very close to them, done in white paint. This spontaneous mixing of the two media leads me to my next point, which is that crayons do marry very happily into almost any of the other media families.

The use of wax crayons with other media

Crayons lend themselves ideally to pattern work, or to the decoration of large masses of colour—in stripes, spots, dots and dashes, etc. As I pointed out previously, this kind of work can become too repetitive, and should, if possible, be put to use somehow. There is, nevertheless, a legitimate excuse for using pattern work for its own sake when experimenting to see what crayons will do when mixed with paint, ink, chalk and so on. Such exploratory work can soon be turned to good account. For example, most Infant classes these days make their own free story books, or at least keep diaries, so why not make a book jacket for each one? All the teacher need do is to cut the paper (or stand by while the child measures it and cuts it himself), and then suggest the way to start. The paper should be left lying flat, and the child asked to divide it into bands with a piece of chalk. There is no need for him to use a ruler, or even to attempt straight lines if he does not want to. He can use wavy ones or zig-zag ones, or a mixture of any kind if he likes. Now he can paint each strip with a different colour, as carefully as a child of this age can. It will not be very neat, and the chalk will show through, but this will not matter in the very least. Now leave it to dry. (When dry, it will, of course,

have curled a bit. This is of no real consequence, but if the teacher can find time to pop it under a pile of books or something weighty overnight, the next session of work on it will be much happier.)

Now, with a wax crayon, the child can simply superimpose all sorts of finer, texture patterns and decorations on the coloured bands. The variation one can obtain is limitless.

For another jacket, place the bands vertically and notice the difference this makes; or use the round pattern that grows outwards from a central dot by adding lines and then joining them up. For this, simply start with a dot, in paint. From it draw six short lines and join them up; then draw six more lines and join these with a different kind of line; and so on until the edge of the paper is reached. Next paint each enclosed shape with a flat wash and, when dry, apply texture with the crayon as before. In the Junior School, ink may be used instead of chalk and paint, and even more new effects obtained. The experience of pattern and decoration gained in this way will show itself again and again in all sorts of ways as the children develop. In pictures alone it will be well worth while, for it not only draws the observation of the child to natural examples of pattern, but gives him a way of recording such decorations found on leaves, for instance, or on the texture of buildings, on furred and feathered creatures, or on materials worn by himself or other children. Crayon added in this way also helps, very often, to pull together a picture in paint that has tended to 'get lost', or is at least too imprecise to satisfy the child.

It will not be long before the children discover that, though you can put crayon on top of dry paint, you cannot put paint on top of wax crayon. This discovery usually intrigues them, and again it can be turned to good use. This is the 'wax resist' notion and, without going into any elaborate preparation, they can do all sorts of things with it.

Patterns using the principle of 'wax resist'

They can draw patterns with a crayon, and then wash the whole sheet of paper over with thin water colour, powder

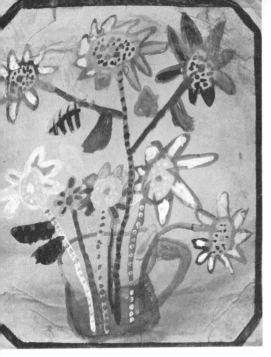

Fig. 5. A vase of flowers painted by a five-year-old boy *(greatly reduced)*

Fig. 6. 'Me and my mum in the garden' *(A fair copy for reproduction purposes, greatly reduced)*

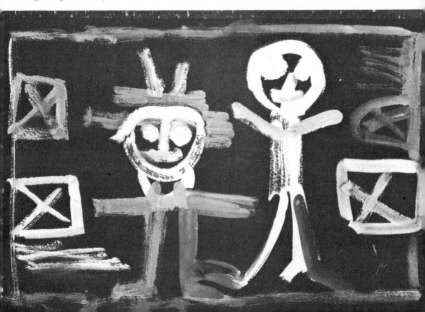

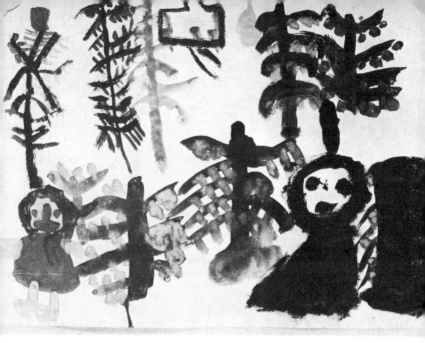

Fig. 7. 'The witch in the wood' *(greatly reduced)*

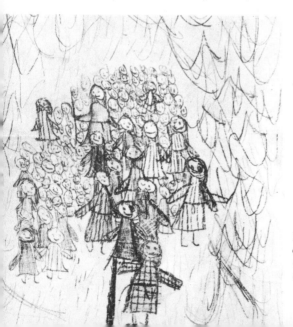

Fig. 8. The Israelites crossing the Red Sea, drawn by a six-year-old boy

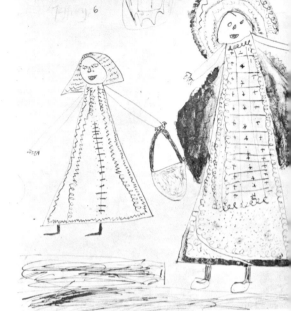

Fig. 9. 'The Annunciation', drawn by a six-year-old boy

Fig. 10. 'Beasts and all cattle', by a six-year-old girl

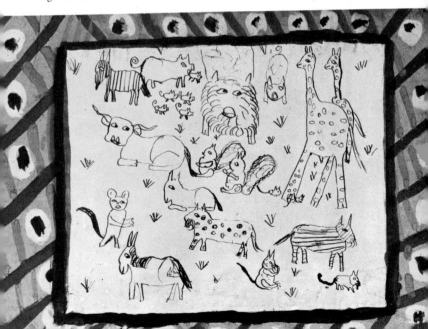

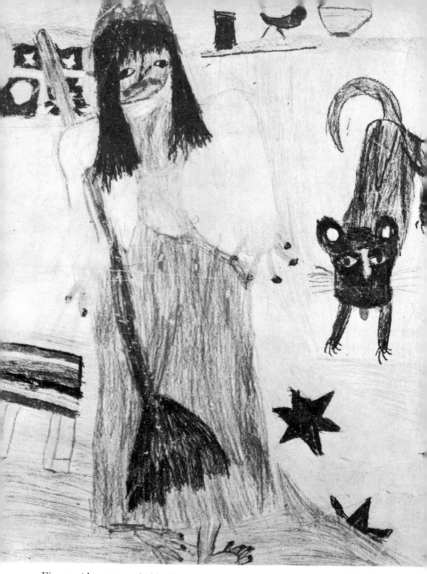

Fig. 11. 'An angry witch', drawn in wax crayon by a seven-year-old girl

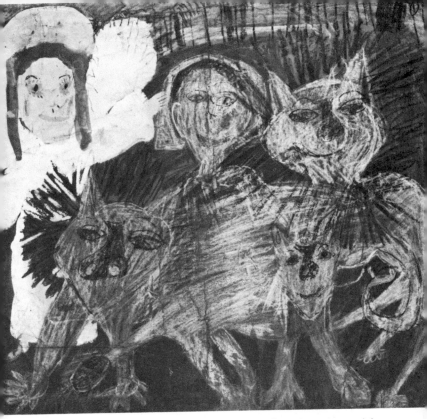

Fig. 12. A wax crayon picture, 'Daniel in the lions' den', drawn by an eight-year-old

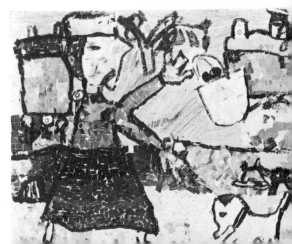

Fig. 13. 'Mrs. James goes shopping', by a girl of five-and-a-half

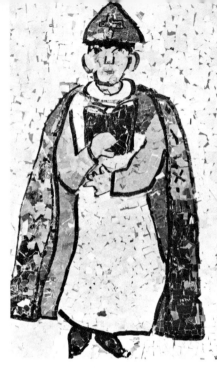

Right: Fig. 14. 'The abbot', worked in paper mosaic by two eight-year-old boys

Below: Fig. 15. 'Funny cats'

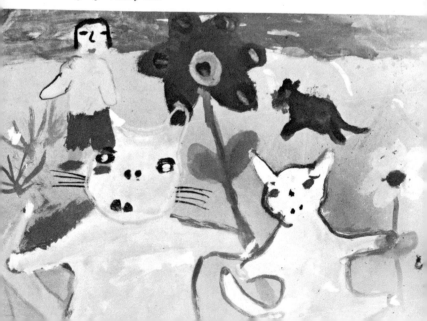

colour, or diluted ink, and watch the waxed pattern pop up through the colour. They can try exactly the same thing on a piece of cheap, white cotton material, first pressing hard on the crayon, then dipping the material into a cold-water dye. They can look for things with texture or pattern on them, such as a brick wall, a rubber doormat or a tree in the playground, and take rubbings of the texture with a crayon, showing it up by washing over with colour, as before. They can apply the experience thus gained when making pictures; for example, the effect of white wax clouds in a blue painted sky is delightful. I have in my collection of children's paintings a large picture of Jacob's Ladder, executed by two seven-year-old children. It is about 20 inches wide and six feet long, and shows a ladder with God at the top and an angel standing on every rung. Because of its size, the children had to work on the floor, which was a very ancient wooden one. They attempted to crayon the angels' wings with white wax crayon, but all they got was a rubbing of the grain of the floor. They excitedly exploited their discovery, and washed the rubbings over with thin, white paint. The result is certainly unusual.

Crayons can also be used with an ink outline. It is a fallacy to suppose that they cannot be mixed to get shades and tints, though I agree that this is difficult to do well. On the other hand, their property of being able to coat thickly one colour on top of another has a value of its own. If one colour is laid smoothly on a shiny-surfaced paper, and another colour laid very thickly on top, the upper one can be scratched off with some sort of a tool—a skewer, an orange stick, a screwdriver or an old metal lettering nib—to leave a pattern of the under-colour showing through. Suggest, for instance, a tropical bird with its feathers done in this way, or a butterfly's wing patterns, or the grass and flowers in the foreground of a larger scene.

Thus, used imaginatively, wax crayons justify their place in the classroom.

6 Collage

The ways of picture-making which I have discussed so far have been those using the orthodox means of drawing and colouring, but it is almost true to say that one can make a picture out of anything, and that there is no limit to the ways one can find of producing pictorial art.

Children are informed by means of their five senses about the world they have been born into, whether or not that information comes to them as the result of their own exploratory activities. If it does come through first-hand experience, so much the better and more valuable. Of the five senses, we have, in the past, put a special premium on sight and hearing. In doing so, we have perhaps neglected the importance of the other three, particularly the sense of touch. A great deal of information about the nature of things is conveyed to a child through his fingertips, and aesthetic discrimination and appreciation may be just as valid when made by the skin, as by the eye or ear. It serves more purposes than the direct one of artistic activity, therefore, to have at hand in the classroom as many different varieties of things to be felt and handled, as well as looked at, as possible. Beautiful textiles varying in thickness, colour, design, and texture, made of as many kinds of fibre as possible, should be part of this collection. Such materials and objects often satisfy unclassifiable cravings in many a child.

I went to school myself for the first time when I was nearly

seven, after a long spell of ill-health. On my first morning there, I was put down among the smallest Infants and told to count out a hundred tiny cowrie shells from a bag. I could count perfectly well anyway, but I did not do what I was told and incurred the severe displeasure of the teacher. She was a friend of the family, and knew quite well that I could count, so she concluded that I was being deliberately stupid, lazy or disobedient. She was quite wrong. I was thrown into such a stupor of exquisite ecstasy by the shells, which I had never seen before, that I completely forgot where I was or what I was supposed to be doing. I just held them in my hands, touched them against my cheek, lips and tongue, and finally spread them out in front of me and gazed. I had been a lucky child, with almost everything I had ever wished for, but just one of those shells to take home in my pocket that morning would have translated me, spiritually, to heaven. I have never forgotten it, and still feel the same about those tiny shells now. A little boy I once taught felt the same way about my green leather manicure set. To hold it, to undo the clasp and see the tiny silver scissors against the velvet case was the biggest thrill he could have. I have also seen the same expression of ecstatic satisfaction on the face of a middle-aged man cradling a medieval sword from his collection in his arms, and on the face of another tough old farmer standing with the first primrose of the year in his hand. To a lesser degree, one child in a class may be uplifted by the sight of a piece of pink satin, another by the touch of velvet, another by the richness of gold brocade. This sort of feeling is a rare and beautiful thing, and educational in its own right. Just to have the things there, would be good, even if they were never used to make any sort of end product. But children also love to be *doing* things, and seem to feel that they have, in some way, made objects their own when they have used them. Moreover, only by actually handling things and by trying to impose some control over them can the children be fully informed of their nature and properties. They have to learn by experience, for instance, the different techniques required merely to stick down to a sheet of paper such disparate materials as tissue paper, silk, straw, feathers,

or sequins. From an educational, as well as an artistic point of view, therefore, collage is a 'must'.

'Collage' means 'sticking' and by it I mean the practice of assembling together, on a background, materials varying in nature, colour, shape and texture, stuck down to make a design, pattern or picture. That is a definition wide enough to allow for a good deal of individual interpretation and scope.

Collecting suitable materials

Before such materials can be used, they must be gathered together, and this is by no means as easy as it may sound. The children will collect, of course, if one asks them, but this is fraught with all kinds of difficulties. For example, I was once presented, on the very same day, with a box full of exquisite scraps from one child's mother who had once been a society dressmaker, and a newspaper bundle containing an apron that another child's mother had, until the previous week, worn for her cleaning job. How could one say that one was acceptable, and the other not? We should not deceive or try to hoodwink children, even if it were possible. They can fairly safely bring 'oddments', such as buttons, beads, feathers and bits of ribbon and paste jewellery; but material has to remain largely the teacher's responsibility. Some of it can be obtained in the normal way by allocating part of the requisition allowance, but most of it has to be 'scrounged'. One's friends, once they know the need, will collect and usually enjoy doing so; some shops will sell cheaply, or even give away, scraps from their workrooms; jumble sales are good hunting grounds and if you know a dressmaker, you are indeed in luck. The scraps collected should be trimmed, ironed and stored in a set of boxes. A ragbag will not do. Oddments should also be sorted into boxes and appropriately labelled.

Small children will generally, though not always, think of making pictures rather than patterns. For these, the child must have a piece of paper for the background, and this should be reasonably tough. Kitchen paper is not suitable, and the

cheaper sort of sugar paper is apt to break under weight and may be disappointing. Each child needs a good pair of scissors that will cut. There is no danger in sharp scissors if they have rounded ends, and a bit of mischief has to be risked, whatever the activity, in classes as large as they are today. There must also be available a selection of different kinds of adhesive. Help will be needed, and guidance, about which of these to use with which material. Soft, thin materials will adhere well and cleanly with the 'Polycell' type; wool, velvet, brocade and so on will need the paste sort, such as 'Gripfix' for instance; card, straw, leather, feathers will require 'Cow Gum' or 'Copydex'; and pebbles or jewellery, beads and buttons, 'Evostik' or something similar.

The composition of the picture

My own way of starting the child off is to let him draw a very rough outline of the main subject of his picture with a piece of chalk. It gives him some idea of his composition before irrevocably sticking anything down, and also guides him a bit with regard to the size of the piece of material he will need. It is far too much to expect an Infant to be able to cut his cloth to fit this outline, though Juniors will often take a pride in doing so. But that does not matter—the outline can always be rubbed out or covered up. Some children like to cut themselves a newspaper pattern of the shape and size they need, and to measure and cut the chosen material by using this as a template. When the child is ready, the moment comes to find a suitable piece of material. There may be pitfalls here, too. The intrinsic attraction of certain materials for him may overcome his commonsense, and Dad digging the garden may turn out to be dressed in gold lamé, pushing a blue velvet wheelbarrow in front of a white lace council house with black fur windows. This is one of those difficult occasions when the teacher has to make a snap decision as to whether or not she should interfere. Must one always accept what the child does as right? Like everything else, 'it all depends'. If one asks a child to draw a fish, and he produces a yellow square with a

green dot at each corner, one must accept it; for one thing, there is no way of telling that a fish does not look exactly like that to him, and for another, even if he sees a fish exactly as we do, we cannot know but that he thinks he has reproduced it accurately. But in the case of Dad digging the garden, something has come between the child and his conception, between him and a reasonable execution—the attractiveness of the material itself. So I should vote for advice and guidance as to which material to use. Perhaps handling the other fabrics and laying them carefully back in the box will be enough to satisfy him.

Cutting out the materials

Actual instruction will also be needed when he comes to putting his pattern down on to the material and cutting round it, for many children seem to have an exasperating habit of placing a pattern right in the centre of a piece of material, and wastefully cutting round it. After all, this cutting and handling of materials is 'needlework' in its earliest stages, and as such has an added importance.

When the piece is cut out, paste the background paper (not the cloth) with the appropriate adhesive, and stick the cloth down, gathering it up into shape if necessary. All sorts of ideas will come to child, as well as to teacher, as the picture grows; the idea, for instance, that pink blotting paper is suitable for making faces and hands.

It is all a rather slow process, and the chances are that when the main objects in the picture have been stuck on, the child will have had enough. If so, he should, I think, be allowed to complete it in any way he cares to, using paint or crayon or ink. In this way he can quickly add details such as eyes, a nose, a mouth or hair, or add windows and chimneys to a house. Some children seem to feel the need to pull this sort of picture together by putting a bold black outline round the rather jagged edges of the stuck-on pieces. I have never objected to this—in fact, I thought it often added to the richness such pictures can achieve. The background will probably have become a bit

messy, and may need cleaning up before being filled in. To fill a background with paint is not always desirable, so, for safety, I suggest a crayon used on its side.

Attempts at this sort of work in the Infant School are bound to be crude, but marvellous things are in store for the Junior School if the children have served their apprenticeship in using scissors and adhesives, etc., while still Infants.

7 Paper mosaics

One of the cheapest and most colourful ways of picture-making is the method usually called the 'paper mosaic'. The term 'mosaic' actually means, of course, a form or work of art in which pictures are produced by joining together minute pieces of glass or stone of different colours. In such genuine mosaics, like the magnificent Byzantine ones at Ravenna, the effect is largely produced by the tiny spaces left between the scraps of colour: the 'broken' effect is part of the whole work of art. To simulate this effect with pieces of paper instead of the glass and stone—and it can be done—great care is needed in cutting and sticking down each little bit of paper to make it relate, in spacing and colour, to all those surrounding it. The placing of squares of paper, for instance, into a curve for the halo of a saint is an exercise demanding some degree of mathematical understanding, as well as skill in patient manipulation; by its very nature, therefore, it is unsuitable for Infants and achieved only rarely by persevering Juniors. I, personally, would not attempt to reproduce this kind of 'real' mosaic effect except with the top class of a Junior School, and then only as a piece of co-operative work in connection with a theme or with history, when the accuracy of the end product was more important than the joy of doing it.

One can, however, use a 'mosaic' kind of technique for picture-making which is quite suitable for young children,

though again I have certain reservations which I will make clear. In this second way, the actual pieces of paper are used merely as an alternative medium of colour, and the effect when finished is that of painting with paper. Also, the small pieces of paper are not necessarily cut to uniform size or shape and, when stuck down, are allowed to overlap to form a solid block of colour. One can easily understand how much less exacting and how much more of a pleasure this becomes to a small child. A curve on a face or a halo can now be easily and speedily achieved, and it causes no frustration or impatience in the youngest or most clumsy-fingered artist. Even so, this kind of picture-making is somewhat slower in execution than a straight-forward painting or drawing, and I do not advocate it for children under seven except when individual children express a keen desire to be allowed to try it, or as a group effort when many little hands busy on one piece of paper make short as well as light work of the task. If a five-year-old begs to be allowed to 'do a picture' in this way, I see no real reason for wanting to stop him. He should be advised not to attempt anything too large, and encouraged to begin on something fairly simple and direct, such as 'a big bird' or 'a green lorry'. He must, of course, be shown the technique. If, when the main object in his composition has been filled in with paper, he shows signs of flagging interest, he should be persuaded to finish the picture quickly by using some other medium. When making a picture of a bird, for instance, a blue sky background could be added in paint; or, in the case of a lorry, a crayon could be used to outline difficult things such as wheels, to put in the driver, and to draw in the street behind, in order to make a finished picture of the effort that has already been made in mosaic work. To make the experiment is important to the child, and it is equally important to him, and to his teacher, that he should not be put off this medium for ever by boredom or failure in his first attempt. Fig. 13 is the work of a girl of five-and-a-half who begged to be allowed to do 'a picture of Mrs. James going shopping' in mosaic. She went a very long way towards completing it before giving in and adding the last few touches in crayon.

Choice of materials and subjects

If one is to use this medium successfully, one must give thought to the choice of materials and subjects to be treated in mosaic, as well as to the method of working.

I have seen many so-called 'mosaics' in Infant Schools and, though I do not doubt that they may have occupied small people very happily for half an hour or so, one has had to admit that many of the pictures revealed neither skill nor aesthetic value. They were usually made of the glazed, gummed-back brightly coloured paper offered by many suppliers of educational goods, and purported to represent 'a windmill' or 'a soldier'—though by the shape of the object alone one would not have known what it was meant to be. Now there may seem to be a contradiction here to what I said previously about accepting what a child calls 'a fish' *as* a fish, because we do not know either how he sees a fish or whether, in fact, he thinks what he has drawn represents a fish. So, of course, it may be with a windmill, but this stage really belongs to the very youngest children, and, by the time a child has enough forethought and perseverance to make a mosaic, he should be past this stage of development; therefore, if he attempts a piece of art that is representational, it should also be reasonably recognisable. If the sketch of a windmill bears no relation whatsoever to such a shape, then the child ought not to be trying anything as difficult as a mosaic. Also, in many of the attempts I have seen, the children have torn the paper into small pieces, instead of being allowed to cut it. I feel that tearing this kind of gummed paper is difficult enough in any case, but the effect of this on the mosaic is bad because one cannot usually tear the paper without getting a white edge showing round the colour. Then, if the pieces so torn are stuck on to a grey background paper, for instance, the white becomes obtrusive and draws attention to the bittiness of the design rather than to its unity. This is important if the work is intended to be 'a picture', and in that case there must be some attempt to add a background composition, so that the windmill stands in a landscape, for instance. These 'Infant' papers are usually in a very limited

range of colour, and each sheet is absolutely uniform in tone, so there is no possibility of any play with a variation produced by the colour itself. I believe that the best paper for this purpose is that obtained merely for the asking—the coloured illustrations in colour supplements and women's magazines. In these, the colour is very varied, often beautifully subtle, and broken by an unlimited variation of texture patterns, for example, the pile of a carpet in an advertisement, the grass in a rural scene, the print of a dress pattern. This broken-textured colour is experience of great importance to children learning to use other kinds of art material. Let us suppose that a child wishes to put a brown horse into his mosaic. Looking through a colour supplement for brown paper with which to colour it, he may come across an advertisement for boot polish showing a full-page picture of a pair of shoes in brown leather, in which the colour varies from deep purply-brown to the gleaming highlights on the polished toes, the whole range of browns being in a smooth unbroken gloss. On the cover of a woman's magazine, there may be a cover girl with brown hair rippling loosely down to her waist—again the whole range of browns, but this time with the texture of the hair added. Which shall he choose? Each would make a splendid horse, but an entirely different one; and the variation of horses that could be made from a mixture of the two is limitless. When they have been allowed to experiment freely, children are quick to see the enormous possibilities offered by this medium and, once they are accustomed to the richness of the broken colour, they will never again be satisfied with a flat wash of paint or with the plain, commercially produced coloured paper.

The choice of adhesive is also important. It must be cheap and clean in use. Runny gum is obviously no good, though I have seen children trying to use it for this purpose; the mounting-paste type is too dry, as well as being too expensive. For this medium there is nothing as good as the various types of paperhangers' pastes, the modern plastic sort being the best of all, and the cold-water mix ones perfectly adequate; if all else fails, there is nothing wrong with grandmother's flour-and-water paste.

Method of working

I believe that, to a small child, half the fun of doing a mosaic lies in the cutting, and what I said before about scissors applies here too. The pieces of colour are cut from the page in areas as large as possible. I always gave each of my children a whole magazine, or even two, to start on, asking them to cut out the areas of colour they thought they would need, leaving the rest of the journal intact. This means that other children can use the books for different colours if their own does not happen to have the exact piece they require, and it also prevents a mass of unwanted scraps of paper from being scattered on the floor. When the selection has been made, the books can be tidily set aside, and the irregularly shaped pieces of colour pinned together with a paper clip or placed in an old envelope until needed. The actual cutting of each large piece into smaller pieces is done only at the last minute, as required.

The background paper should be reasonably strong.

It is no use starting too big a mosaic, but it is equally foolish to begin one too small, so at least half a sheet of sugar paper must be allocated to each child. The bold outline of the central object of the picture is drawn with chalk. Let us suppose, for the moment, that a child wants to make a guardsman. He must be encouraged to 'draw big', and not to fiddle with details which, in any case, will be covered as soon as the paper is applied. When all is ready, *a small area of the background*, the guardsman's busby, perhaps, is pasted. The appropriate colour is taken from under the paper clip, cut quickly into small squares and, while the paste is still wet, stuck down, overlapping to make a solid block of colour. This continues until the whole picture is built up. It is surprising what fine details the fingers of little children will achieve in this way, and how nimble they can become in cutting, pasting and sticking, with the result that quite a large picture can be built up in a short time.

Further practical suggestions

One last word of advice, and two of warning.

In the process of sticking, there usually comes a stage in

which the picture 'gets lost', and the child may become disappointed and wish to give up. It may be necessary to explain to him that there is a way of pulling the picture together again when the sticking is all done. This is by the use of a black outline, executed in paint round the main objects in the composition, which is perfectly legitimate in a picture made with paper or cloth, though not in one done in paint or crayon.

Secondly, it may seem tempting to cut the large areas of colour into the tiny pieces before beginning to stick, but this is not wise in practice, because a draught from an open door or the sleeve of another child passing the desk may sweep the whole lot away into a hopeless muddle on the floor.

Lastly, there is always a danger that the more intelligent children will take short cuts to difficult parts by cutting out whole the eyes, mouth and so on from, perhaps, a cover girl picture and applying them untouched to their own creations. The result is ludicrous, more often than not, but the temptation is great, and I have actually had to forbid this in specific terms in order to prevent lovely work from being ruined at the last moment. On the other hand, I have seen blackcurrants or gooseberries from an advertisement used with palpable success for eyes.

By the time the children are seven years old, this wonderful way of making pictures is added to their skills, and there is practically no limit to what can be achieved by it. Fig. 14 is a reconstruction of a 15th-century fresco on a church wall, carried out by two rather slow boys of eight working together.

8 What shall I paint?

It is to be hoped that in these days any painting or other sort of picture-making done in the Infant School is a spontaneous activity, arising from the children's desire to express their individual response to their environment as imaginatively and as creatively as possible. When this is so, the answer to the question 'What shall I paint?' is usually in the child's head before his feet begin to carry him towards the place where the art materials are either laid out ready or stored within his reach. But this is not always the case, because it may be that delight in the materials themselves sets up in the child the desire to use them when, in fact, he has at that moment no particular impression of anything he wants to record. So he turns to his teacher, who has probably a thousand other things on her mind anyway, and asks her to suggest what he shall paint. Quite often the nature of this request is misunderstood by the busy teacher, who answers, 'Oh, just anything you like', imagining thereby that she has given him what he was asking for, a *carte blanche* with which to go ahead. The chances are that this reply is literally worse than useless to the child, who is asking for assistance, not liberty. There is, I feel, nothing more defeating than too much freedom in the matter of choice. Unless one has something specific in mind to act as a guide, the infinity of experiences from which one could choose simply causes the imagination to boggle and all power of selection

to wilt. We all know what happens to a child in a situation like this. In desperation he falls back on something he has done before with interest and pleasure (perhaps having earned a word of approbation from his teacher into the bargain), and hopes thereby to recapture the same desirable results. He fails, of course, because the freshness has gone out of the activity; he is disappointed, and less willing to turn to paint again. I have seen teachers who are aware of this emergency prepare themselves against it by cutting out, by template, dozens of objects such as butterflies or birds or kites or dolls' houses, and handing these out to be coloured. I hate to be hard on such a well-meant attempt to deal with the situation, but the fact remains that this must be seen for what it is, a mere expedient to keep the child occupied for a few minutes. It gets him nowhere and does nothing either for his development or for his aesthetic ability.

In the Junior School, the picture is slightly different. One hopes, of course, that art is an integral part of whatever 'education' is afoot in any Junior classroom, whatever the lesson according to the timetable. But unfortunately, in a great many of the Junior Schools I know, 'Art' is a lesson on the timetable, as is History or Physical Education, taken at a specific time two or three times a week. At the same time, such 'art' as is used in the other lessons tends to be quite divorced from the art lessons proper, and usually becomes stilted illustration.

The art lesson

Now while believing wholeheartedly that all knowledge is one and indivisible and should be treated as such, I have never been against all the children in a class giving their attention to the same thing at the same time, provided that real interest is there and that the time is usefully employed. In particular, I have never been against a proper art lesson if this means that there is a chance for children to practise art, with no other axe to grind, under the control of a teacher who knows what he is about and who uses the time to explore new techniques or practise old ones in a manner that will be of value to the rest

of the subjects in the curriculum, as well as for its own sake as art. Whatever the technique in use, there will always be children with ideas of their own which they want to explore in this medium, but there will also be a great many with less fertile minds who find it difficult to produce an idea at 2.30 p.m. on a Thursday afternoon just because the timetable says 'Art' at that time. These children should not be left to flounder in a morass of indecision any more than those who are bursting with an idea of their own should be ordered or coerced into doing what the teacher has thought up as a good subject. Art is too important a part of education for any risk to be taken of the children becoming bored or of merely filling in time. So we have three separate categories of children to think of:

(a) those who know what they want to paint;

(b) those who want to paint but don't know what;

(c) those who are required to paint because the timetable or the teacher says they must.

If we are to be able to help those in (b) and (c), it will be wise for us to take a close look at what the children in (a) do.

Children with imaginative ideas

When these children are exploiting their own imaginative ideas by practising skills with which they have become familiar in their own way and at their own pace, the variety and depth of the subjects they tackle is surprising, to say the least. They do not produce houses with a window at each corner and a door in the middle, or endless repetitions of the same sort of car, aeroplane or tractor. Instead, from some inner depth of stored experience or imagination, aided by eyes already being trained to observe accurately and by information supplied by the sense of touch and the joy of movement, subjects appear on the paper that no teacher would have thought of suggesting, subjects such as 'God looking into a bird's nest' or 'Grandma scrubbing her false teeth', (both offered to me by six-year-olds in the past!). Sometimes the teacher may have difficulty in

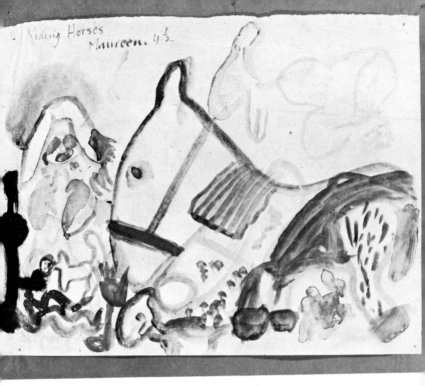

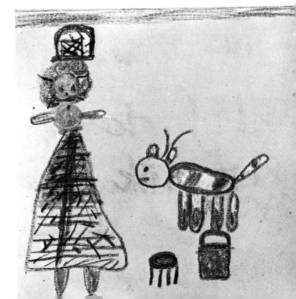

Fig. 18. A picture and story by a girl of five-and-a-half

Rose and Primrose had a fairy apple tree in the middle of the wood. One day they saw a little boy who had taken one of the apples.

Cows

Angelos' cows trundle about
Skipping and hopping like
big does,
Skipping their best.
They seem as if they
are singing
To the trees in the field.

Fig. 19. The work of the same girl, at six-and-a-half: a spontaneous poem decorated with line drawings

Right: Fig. 20. An extract from a free story, based on an historical theme, written by a ten-year-old boy

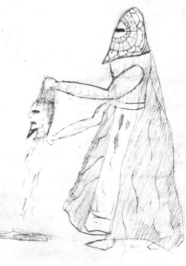

executioner's shoulder, and with all his might the cheif executioner swung the axe back down. Thud! the head of King Chrales rolled off the block into a basket. Then the cheif executioner's assistant picked up the head by his hair, showed it to all the people.

Below: Fig. 21. A page of writing by a six-year-old girl

Thou hast set a bound that

they may not pass over;

that they turn not again to

cover the earth.

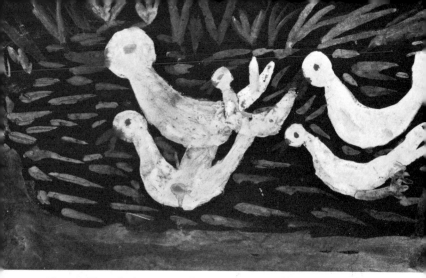

Fig. 22. 'Four ducks on a pond', by a six-year-old

Fig. 23. 'The wind', by a seven-year-old

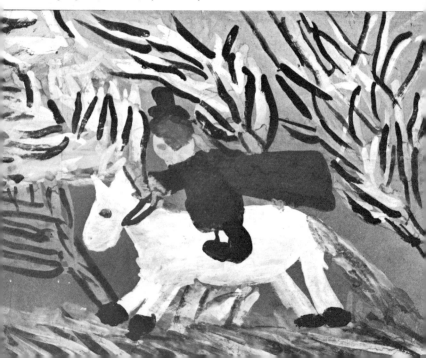

Left: Fig. 24. A detail from a flower panel made co-operatively by children of six to eleven years

Below: Fig. 25. 'A 14th-century cottage, painted by a girl of nine

Fig. 26. 'The King of Nineveh in sackcloth and ashes', by a five-year-old

Fig. 27. 'Elijah fed by the ravens', by a six-year-old

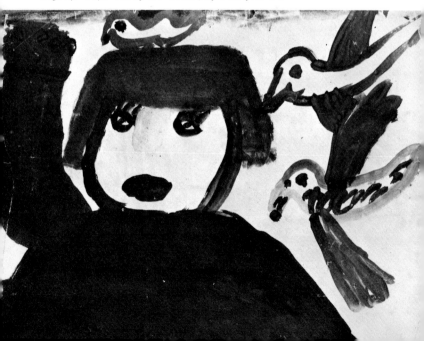

deciphering the picture, which presents a problem when the child has quite obviously been very sincere in its execution and thinks he has communicated clearly. It then taxes all her ingenuity to make appropriate comments, because 'Yes, dear, it's lovely—what is it?' will not do, as it is an insult to the child's intelligence. The only thing one can do is to say honestly, 'I'm afraid I don't understand your picture, Peter. Tell me all about it.' However, this situation does not arise too frequently because, although the subject of the picture may be very strange, in their early years at least children tend towards representational art and, whatever the nature of the imaginative idea, the image of it tends in the child's mind to be clothed with reality. So God will probably be wearing a bowler hat, like the H.M.I. who came the day before, and 'A Nasty Old Witch' will look just like someone well-known to the child. It seems that, in some way, ordinary experiences go into the child's memory and, after hibernating there for some time, reappear as imaginative things dusted all over with fairy gold. Fig. 16 is 'Riding horses', painted by a four-year-old, and Fig. 15 is 'Funny cats', by a boy of seven.

Ideas for subjects

The lesson for us is that these things are all directly related to everyday experience. Those things from the imagination are clothed in reality, and those things from reality clothed in imagination. Whichever way round it is, there is something concrete from which to start. It is the ordinary thing that is the basis of the picture, one way or another. When a child wants help in finding something to paint, it is this that the teacher should try to remember. In the last few minutes I have looked out of my study window for ideas for pictures. Here they are: a bird with wings outstretched flew up against my windowpane; a cat stretched itself up to smell into the half-closed lid of my dustbin; a young tree was bent over nearly double by a sudden gust of wind, and a robin, sitting on the topmost branch, simply clung on; a sick child was looking sadly out of a window; the window cleaner was cleaning my window, and could be

seen from the inside. The teacher who has eyes to see can draw the attention of a single child or a whole class to such tiny paintable incidents at any moment, even inside a classroom. But if she sees them herself and stores them in her memory, she can produce them for the children, who, after all, are used to seeing things through her eyes and by means of her tongue, from the much wider range of experience than their own. The chances are, however, that the teacher has only to put forward one or two such ideas to set the children's own minds and memories working, and they will begin to say 'Can I do me throwing a stick for our Tinker?' All this is equally applicable to the Junior School, where the best pictures often come from the most prosaic incidents. However, time in the Junior School is usually more limited than in the Infant School, and it is wise to have a few ideas in the way of titles to offer for consideration, either to the whole class or to those who have no valid ideas of their own. Verbal descriptions of incidents, such as 'An old man running after his hat' or 'A gipsy with her baby', may prove entertaining as well as helpful to English; incidents from a story may help to clear the child's mental picture of it, and poems are, indeed, a gift in this respect, but I shall deal with this aspect much more fully later on.

There are so many things one could suggest that I feel it would be more helpful if I picked out a few of the things it is wiser to avoid. Chief among *these* I would place any suggestion of illustrating stories that have already been done in a way that the children know and would merely copy—the Walt Disney 'Snow-White' still pops up as art in pictures and puppets and dolls everywhere! It would also be foolish to ask Infants to do their own pictures of the characters of Beatrix Potter, A. A. Milne, or of Philippa Pearce's 'Mrs. Cockle's Cat', for instance; in all these books the drawings are part and parcel of the stories, and any attempt at illustration by the children could end only in disappointment and frustration. Second on the list I would put the 'all-inclusive' sort of suggestion, such as 'A railway station', 'The beach' or 'Oxford Street'. A task like that would frighten a professional artist, let alone a struggling child! Such subjects are best left for

co-operative work. Pictures of scenes from history have to be handled with great care and, unless the teacher is very skilled, I think interpretation of music in picture form, or even in abstract form, is much better left out of the Junior School. These, however, will be dealt with later, and I am only concerned here to give some word of advice to those teachers who may see 'wonderful' abstract work on the walls of other Junior Schools they visit, and think that they ought to be producing the same kind of work. In my opinion, there is no need for this in the Primary School, where children paint easily and freely from everyday experience and the wealth of their imagination; to introduce any adult ways of seeing reality, such as abstraction in pictorial form, is equivalent to what we have done in the past with mathematics, for instance, where we taught multiplication of pounds, shillings and pence before the children could correctly count the change out of a shilling after buying their own weekly comic.

9 Co-operative work

There is a great deal to say about co-operative work, so I propose to deal first with the general principles, the advantages and the difficulties, and expand my ideas later when dealing with art related to the rest of the curriculum.

Co-operative work with Infants

First of all let us take a look at the many different kinds of co-operative work there are. Many teachers seem to think that a piece of work does not deserve to be called 'co-operative' unless the whole class, or at least a large group, has been engaged on it. In fact, of course, when two children agree to make a picture together, they are producing a piece of co-operative work, and this is often the beginning of much larger things. This will happen quite spontaneously in a free atmosphere, where it is allowed for by space and materials; however, children under seven do not co-operate as easily as older children, being absorbed in themselves and their own particular activities. Older children tend to group themselves together in any case, and in such creative subjects as drama, art and movement, this can be put to good use.

Remembering, then, that Infants are not likely to join with others in actually producing one picture, the beginnings of co-operative work can be established by deliberately using individual pictures mounted together into a panel or frieze.

For instance, if each child at some time or other during a certain week is given a piece of paper of a certain colour and a certain size, asked by the teacher to 'fill' the paper with a picture of himself dancing (or with a picture of a clown, policeman, soldier, Indian, cowboy or any other human figure), and all the pictures saved, it is easy to make a frieze of considerable gaiety and interest merely by mounting them on paper of the same sort, overlapping them so that the little figures are close together, and employing one's own ingenuity to make sense of the whole. For example, if the pictures are of children dancing, the figures, crude as they may be, can be arranged into an ellipse, with hands all touching a coloured ribbon drawn in by the teacher, to give the desired effect. Similarly, policemen could be forming a cordon, shoulder to shoulder, or clowns could be arranged to look as if some were standing, some lying, some leaping. When the figures have all been stuck on, background can be added with coloured chalk or crayon (not paint), and other details put in to hold the frieze together. These finishing touches can legitimately be given to those children who are better at using art materials, so as to make the entire effect of more worth.

Now let us look at the advantage of a piece of work such as this over a set of individual paintings all on the same subject. To start with, out of a class of thirty Infants all painting Red Indians, the chances are that only about six will be truly recognisable as such. The six might be displayed, with resulting benefit to the children who did them; but what about the other twenty-four? They lie soggy or curled up on the top of the piano till 'home time', when, after the last footstep has died away, they are dropped into the waste-paper basket. This is not just a question of the achievement of six children: it is of twenty-four suffering defeat and disappointment, though this may be unconscious and not expressed. In the frieze, every child's attempt, however crude, must be included. By judicious juxtaposition of the better ones the poorer ones, every single one will be 'read' for what it is meant to be, and what is more, every child will experience the satisfaction of achievement. If one thinks of the way an adult artist portrays a flock

of birds, for instance, this idea becomes very clear. He draws those in the foreground with care and great detail, and those in the middle in less detail, while those at the back are merely schematic shapes; but the eye reads them all as birds because they are identified with the very recognisable ones in the front, and the mind accepts the whole.

One sees, decorating the walls of Infant Schools, a great many friezes which are produced by sticking down symmetrically, and with careful spacing, shapes cut out by the teacher and coloured by the children. This may be handwork, but it is not art, and if time and effort are going to be given to a frieze of this kind, it might just as well have some real educational value. It must constantly be borne in mind that it is not what goes on to the wall that matters; it is the satisfaction the children get from doing it.

Development of art work from stories

Once the idea has been accepted by the children that, when a piece of co-operative work is afoot everybody's effort will be displayed, there is a real incentive to do well. Moreover, the teacher can begin to develop the first crude attempts, and here the story lesson can be put to good use. After telling the story of Noah's Ark, for example, two of the more reliable children are perhaps asked *to work together* to make an ark at one end of a long piece of paper. They can be told that they may use anything they like to make it—paper, cloth, bark, balsa wood, dead matches, card, laths. The only stipulation is that it must be big, because the rest of the children are going to do the animals going into it. (A bit of movement here would be a great help in getting the 'feel' of the different sorts of animals.) Then the rest of the children should be divided into groups of about eight, partly because the chances are that not more than eight can be painting at the same time, and partly because it is necessary for each in the group to be aware of what all the others are doing. So, if the first eight agree to do the elephants, the goats, the dogs and the rats, there arises immediately the need for group discussion on the relative size of

these creatures. In fact, though they are still going to produce individual pictures for the frieze, they are really already working as a large group. When all the animals have been drawn, they must be cut out carefully. Now comes what is perhaps the most educative part of the whole process. The children discover that one horse is going one way, the other the opposite way. What can be done? How will a couple of Infants solve this knotty problem? Will anyone see that, as the horse is now cut out and therefore a sort of template, all that is needed is to turn it over and repaint the other side? Both the elephants are going the right way; but how can you make them go side by side and still show both children's work? This may be more difficult to solve, and will perhaps need teacher's skill as an arbitrator, but, if the children have mixed their own colours, as advocated in the early part of the book, the shades of grey on the two beasts will be quite different. One may also be slightly bigger than the other, or one have his trunk held above his head and the other straight before him. By laying the frieze paper flat on the floor, the children can experiment with all the possible arrangements of the two creatures until they discover that it is quite possible to show that there are two things side by side, and that in a picture one thing often covers up another. When all the animals have been stuck down, a background of sky, grass underfoot, and perhaps rain and cloud and drooping plants and trees can be added *ad lib*. This example holds good for the Junior School, and can be applied to history, geography, and so on.

Further suggestions

In using the word 'frieze', I have had in mind the long, narrow, composite picture because, for small children's work, this is the easiest to deal with; but there is no reason at all why the square or rectangular panel should not be substituted. For many subjects, the panel is best. If boats or ships happen to be the objects of interest at the moment, or if at Christmas-time the class want to do a picture of the stable with the Holy Family,

the shepherds, the beasts, the angelic choir and the star all represented, then quite obviously a large square panel would make more sense. In the case of boats, the activity would provide a wonderful exercise in perspective—without the word ever being mentioned, of course—for the teacher can make sure that the larger boats were kept to the front and the smaller ones away in the distance at the back. The Nativity scene would offer an exercise in composition, because even the smallest children would understand that the pride of place must be given to the Family, and that all the other things in the story should be grouped sensibly around them.

I know from long experience among teachers that, though they may know very well how to get children to do good work once started, they often get stumped for ideas. This is not to be wondered at, for nothing is more likely to drain one dry than to spend every day in the company of a class of forty or so healthy youngsters; but by the same token, nothing is more stimulating once ideas begin to flow, and it must be realised that, just as one can make pictures out of almost any material that happens to be at hand, so one can use almost any story, song, poem, cumulative folk-rhyme, lesson or anything else, for the germ of a piece of co-operative work. 'The Twelve Days of Christmas' is a good example. This can be done as a frieze, with a pear tree marking each day's offerings; or as a panel, where the tree can occupy the whole sheet and each day's offerings can be mounted on successive branches; or it can be done as a book, and I would like to stress the book as the very best and most useful way of doing artwork co-operatively.

Making a book

The book itself can be made of good sugar paper or cover paper—or some kind of paper that will stand up to a good deal of handling, for there is a good chance that this will be very popular as a reading book. If a folded sheet of paper is not large enough for what is envisaged, then larger sheets, stuck together with a very strong adhesive down one side, can be

used. (A fold should be made in each sheet to allow for turning over, but it is wise to remember that very large books are difficult to handle.) Simple sewing with strong thread or weaving cotton is, in my opinion, still the very best way of fastening the pages together, although rings and long-arm staplers can be pressed into service by the busy teacher. When making a book with children, the secret is not to work directly into it, but on to sheets of paper cut to size slightly smaller than the size of the book page. Then each piece of the rhyme, song or story can be interpreted by a child and, when completed, stuck into the book by a tiny touch of paste applied to the four corners (*not* all over the back, which makes cheap paper wrinkle); a border or frame round the mounted sheet adds to the finish, and the teacher can either print, write or type the appropriate words below, or on the facing page. Cumulative rhymes are very good for this activity, because the objects are often simple and the words repeated over and over again. A rhyme like 'O, the dust on the feather . . . and the feather on the bird . . . and the birds on the nest . . . and the nest on the branch . . . etc.', or a song such as 'Up was I on my father's farm, On a Mayday morning early, Feeding of my father's sheep . . .' (cows, pigs, ducks and so on till invention or the book runs out) provides not only a vehicle for art work, but also illustrates the point I keep reiterating: art, used properly and constructively, can be the best of all teacher-aids in the world.

10 Art, Calligraphy and English

There is an obvious link between Art and English because both are forms of communication, and, though English may become the more important as the children grow older and progress up the educational ladder, in the early stages pictorial art is perhaps the more natural and more easily understood. It seems, for this reason, that this progress should be in three stages:

(a) when picture comes first, accompanied by a few words;

(b) when both are equally important;

(c) when the picture is an added embellishment to the words.

Such is the pattern followed by people who write story books for children, and I think teachers who follow their lead in this are wise. So, in the very earliest stages, the children's own attempts at communication through picture-making can be turned to good use as an aid to English. As we have already discussed, this may take the form of the child talking in a monologue (not intended for anyone else) whilst actually painting. This should not be disparaged as a means towards verbal expression; indeed, the fact that it is spontaneous may be its strength, and words, though few in number and oft repeated, may in this way become properly articulated, while at the same time the whole range of meaning modulated by intonation is being unconsciously explored. For example, 'I am going to draw my dad's lorry. It's a big, big red lorry. Did you know my dad drives a big lorry? I'm going to go with my dad

on his lorry next week. My dad's lorry is a big red lorry,'—and so on. Now the chances are, I think, that, whether or not the child actually says the words aloud, the thoughts that prompt such monologues in some children in certain situations pass through the minds of all children in all situations, and articulated thought is only one step before articulated words and sentences. One of the worst features of the old-fashioned 'composition' in the Junior School, set by the teacher and 'prepared' by the children before putting pen to paper, was that, in such compositions, neither thought nor words flowed with any sort of natural order or ease: both were stilted and artificial. A child talking to himself or *thinking to himself* about an activity such as making a picture or modelling in clay, is doing so in natural order and ease; thus, the more activity of this kind that there is in the Infant School, the greater will be the basic capacity for communication in words when this is required in written form.

Introducing the written word

When the first 'exploratory' stage of art work is over and pictorial representation begins to take its place as a means of recording impressions of the environment, it is legitimate to talk about the children's pictures to them—provided that such a conversation is not pushed beyond its very narrow limits. Two or three sentences usually reach the limits, and anything further is pointless to both teacher and child. Now, however, is the time to begin to introduce the written, or printed, word. I find there is no better way of encouraging both reading and writing than to use rhymes, riddles, songs and jingles, with which the children are verbally familiar and which they connect with pleasure, to illustrate, caption and make into a book. Fig. 17 is from just such a book, made by a child of barely five years old, on the rhyme, 'The House that Jack Built'. An accompanying appropriate caption was written by the child herself on the opposite page. Some nursery rhymes may prove difficult, but there are plenty that are within the range of even the smallest Infants, e.g., 'Three blind mice', 'I saw three ships'

(nursery rhyme version), as well as age-old counting-out rhymes such as 'One potato, two potatoes', 'Dip, dip, dip', etc.

Calligraphy

I must here, I feel, interpolate a few thoughts about children's calligraphy. There are several schools of thought about what sort of typography should be used both for, and by, children, and much work has been carried out in this connection, especially just recently with the reintroduction of the initial teaching alphabet. Much of the argument is in favour of matching the child's own script to the form he sees in his reading book, or vice versa, as it is claimed that this is less confusing to the child and that his writing and reading fuse together in his mind. I know that in theory this method has much to commend it, and I should hesitate to try to persuade anyone to change; but nevertheless, I shall give my own view, stating the objections which can be raised. One is that, whatever style of Infant script, approximating to a printed type, is used, this script has, at some time or other, to be unlearned and a proper cursive hand taught, otherwise it is joined together into an ugly, hybrid style which is never turned wholly into anything worthy of the name of calligraphy. Maybe, in these days of typewriters, telephones and tape recorders, this does not matter; but, while handwriting is used in schools at all, children must be able to do it reasonably well, and the fact remains that the change-over from script to some form of cursive writing usually comes just at the stage when more and more 'free' English is being demanded of the children involved. To those children with a lot to say, the frustration must be enormous, while, to those who find even a few sentences a struggle, it adds an almost insurmountable difficulty—to say nothing of the effect of badly made letters on spelling.

In my opinion, calligraphy is a form of art; it should be treated as such, and prepared for right from the start. It is as easy to teach a good italic script as it is any other variety, and, when 'writing' is demanded of the children, this style remains a rhythmical script, which becomes to all intents and purposes

a 'cursive' hand *merely as a result of the extra speed at which it is written*. Moreover, the broad-ended tool remains basically the same in pencil or ink. I cannot accept the argument that the use of such a script slows down reading. This may have had some validity in the days when children 'read' or 'looked at' nothing but the basic reading scheme, and when teacher and children carefully made their letters to match; but in these days, every Infant class has, or should have, a library containing all that is best in books for the age range, and, as we all know, the library books differ one from another in typography as the stars in glory. So, the children in my charge practised calligraphy, in the form of italic script, from the beginning, and whatever evidence psychologists and their like bring against me, I can only say that for me it worked, both ways. As far as I could judge, the Infants read just as well and as early as children using other methods of writing, and they wrote better, faster and more legibly in the Junior stages. Thus, my books were always executed in italic. Fig. 21 is a page of such writing by a six-year-old girl, and is from a co-operative psalm book.

Development of written expression

From the rhyme and jingle stage, the children can go on to putting captions with their own pictures, by dictating to the teacher orally what they wish to write and copying what she writes for them; then, as soon as the skill of reading is truly accomplished, they will start making up their own stories poems, accounts of events, etc., first in picture, to organise the thought, and secondly in words. Figs. 18 and 19 are by the same little girl, with some twelve months of school between. In Fig. 18 the picture was done first (at the age of approximately five-and-a-half) and the writing, with help, second; in Fig. 19 the poem was spontaneous, and the delightful bits of line drawing were added decoration as part of the general joy and exuberance of the experience. Some children dispense with the pictures and turn wholly to words for expression, but some retain the picture, either as aid to thought or as decoration,

right to the end of the Junior School. Fig. 20 is the work of a ten-year-old boy, writing a free story based on an historical theme.

Art in relation to literary forms

Stories read to children can be painted either individually or as co-operative efforts. (I shall deal more fully with the possibilities and dangers of this when dealing with Art in relation to Scripture, History and Geography.) So can poems. Fig. 22 is an illustration by a six-year-old, of 'Four ducks on a pond'. Fig. 23 is of 'The Wind', and was painted by a seven-year-old boy who was only just on the border of educability, as judged by normal 'tests'.

One last word about the enormous advantage to both 'subjects' of a liaison between art and dramatic play, or 'drama'. From the latter one cannot, of course, separate movement, and music lies ready to be used with any or all. Aristotle's definition of 'poetry' (by which he meant what we call drama) was 'imitation'. Painting is graphic imitation, drama imitation by movement, gesture, stance and grimace. Poetry adds imitation by voice, in words. No such imitation can take place without acute observation: the good actor is one who has noticed what other people do in certain situations: the good artist is one who carries in his mind's eye some visual observation, whatever use he may make of it on paper or canvas; and the one 'good at English' is he who can remember words and phrases heard or seen and put them to his own use. Whatever might aid such observation, and the capacity to store it till needed, is indeed an asset to real education, and the insight given by observation in one art form throws light on the others. A child who has read a story of a man on horseback will 'feel' the part if some of the basic movements of the horse are explored through movement, and some of the man by 'dramatic play'; if a picture were then suggested or requested, visual observation and imagination would be doubly reinforced, and the chances are, in my experience at any rate, that after that the wheel would turn full circle, and a poem or a descriptive story would appear, unsolicited, in an English book.

11 Art and the rest of the curriculum

It would take me another whole book to deal in detail with the part which art can play in furthering the understanding of other activity or subject work that goes on in Infant and Junior schools, and I have very little space left. The most I can do, therefore, is to try to pin-point some of the general principles of using it well, and also to mark some of the danger spots. As usual, it is much easier to start with the latter.

In the Infant Schools of today, any introduction to social studies or religious education comes under an umbrella title of 'stories', along with stories from literature and poems; work in mathematics and science comes under the blanket coverage of 'discovery', leaving music, drama and art itself under 'creative play activities'. In the Junior School—while attempts may have been made to integrate subjects by using topics, projects or themes—the chances are that more emphasis is put upon each 'subject' separately than in the Infant School, more attention being drawn to factual information and subject matter in the case of social studies, mathematics and science, and greater attention being paid to the techniques and the standard of the end products in the field of creative work. In both cases the aim is to introduce children to a wide range of interests and experience, some of which, lying far outside the limits of their own first-hand knowledge, relies upon imagination for any kind of impact or involvement.

I will deal with the Junior School problem first, and for the moment confine myself to the social studies of history and

geography. Much of the matter of these subjects *must* lie outside the children's own 'experience' in time and space, for by no stretch of 'imagination' could anybody 'know' what conditions were like in the Cameroons or in the court of Edward IV, for instance, if they had not been told or shown pictures and objects. Factual knowledge here is essential, and the knowledge that is imparted must be accurate or it has no validity at all. This is where books come into their own, and in these days there is a wealth of them on practically any and every subject under the sun. Once the children's interest is aroused, they will pore over text and picture in avid desire to know more and more. Some will remember certain details of what they hear and read; others will retain quite different ones. Some may wish to make notes and sketches, others not. The practice in the past has been, and in a good many cases still is, for the teacher to select what is to be remembered and to ask the children to record it by means of word and picture—the pictures not being 'art', but 'illustration', and often copied from a book. These pictures are usually executed in pencil subsequently inked over, and coloured by means of pencil crayons or water colour; and, because they are done in exercise or 'topic' books, they are usually small and either painstakingly neat or else unrecognisable, by reason of lack of interest or poor draughtsmanship. The value of such illustrations *must* be questioned. If there is going to be an examination (which heaven forbid!) or even a test, for which specific facts must be memorised in order to be regurgitated, then to draw such 'pictures' may give the memory something to latch on to, and so serve a purpose of some sort; but as a means of aiding comprehension and of encouraging further interest, they are poor. As 'art' they hardly exist. At best they are time–fillers, or a taste of sugar on the pill of learning facts which are barely understood.

Comprehension of subject matter seems to me to depend upon voluntary involvement by the children through the exercise of imagination, and wide and varied 'experience' of the matter in hand can be gained by approaching it from as many angles, and exploring it in as many ways, as possible. With the

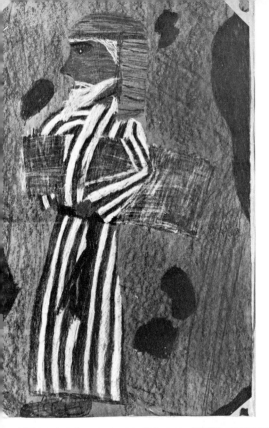

Left: Fig. 28. 'Moses coming down the mountain', by a nine-year-old boy

Below: Fig. 29. 'Palm Sunday', worked co-operatively

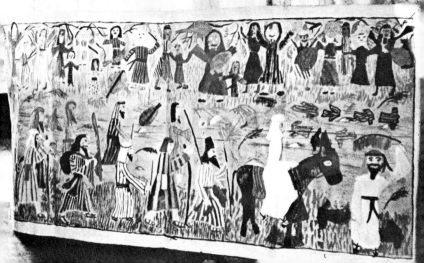

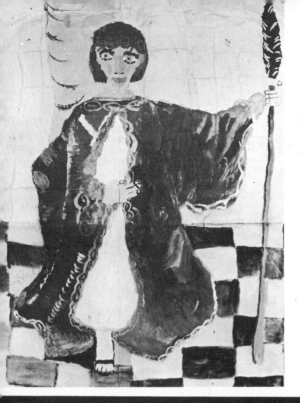

Left: Fig. 30. 'Christ mocked', by a girl of nine

Below: Fig. 31. A picture from a book of illustrated psalms

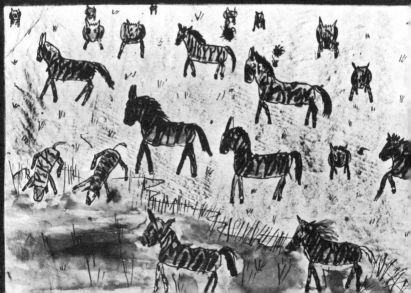

initial stimuli supplied by the teacher and good reference books, much deeper and wider understanding can be gained by using the Arts as stepping stones. Perhaps one or two examples in detail will help to make this clearer.

Let us suppose a large class of second-year Juniors is doing geography about Central Africa. The teacher, with the help of maps, globes, pictures, films, charts, etc., will have covered the basic information, and a selection of excellent reference books will be made available; stories will have been read to the children or written by the children. Will the art work, which will almost certainly be included, be just another activity, or will it really aid deeper understanding and, at the same time, rank as 'art'? If 'illustration' in exercise books will not do, how can it be tackled?

My answer here is that a piece of co-operative work by the whole class is better than forty individual pieces because, while all are engaged on the same major task, information will be pooled, and subjects other than geography will be used. An African market would provide a gay, colourful scene to start on—perhaps it could be a really large panel for the wall of the classroom, as much as six or even eight feet square. (The measurement of the wall serves two functions: it determines the proportions of the finished panel in the children's minds, and puts mathematics to good use in deciding how many sheets of paper of a certain size will be needed to make the background.) When it comes to deciding what to put into the picture, it will be discovered that a great deal of geographical knowledge is required. The teacher, acting as general organiser, will ask the right questions, for example: What goods will be for sale (a) by the Africans, (b) to the Africans from the larger world outside? How will such goods be taken to market? What sort of people will attend the market? How will they get there? Besides buying and selling, what else might be going on there?

Information gained from reference books by individuals will supply answers informative to all, and build up a view of Africa today in its significant complexity of old and new. At this point, each child can choose one sort of ware to be displayed and, bearing in mind the dimensions shown to him of the

finished co-operative panel, make a picture of it—piles of oranges, heaps of cassava, hands of bananas, bolts of cloth, galvanised buckets, plastic bowls and so on. This work is done *on the child's own desk*, and subsequently cut out and stored. Now, keeping proportion in mind, the child can paint the person *selling* the wares. Will he be African or European? Standing or sitting? Next, some buyers taking the goods away. Will they wear African or European dress, or a mixture of both? If they have bought goats, they will have to drive them; a plastic bowl would be filled with maize, perhaps, and carried off on the head (dramatic play would be very useful here). Others may be riding cycles or driving trucks. Then the crowd at the market—what would they be doing? Standing or sitting? kneeling or crouching? Some would be holding children by the hand or carrying babies on their backs; some offering goods or money to each other; some lifting heavy loads, eating or drinking, dancing or drumming, and so on. If the child can't think what a person would look like crouching, for instance, he can get someone to mime it for him before he starts.

By this time, a great deal of material will be ready for mounting—more, perhaps, than can be applied to the space made ready for it, so some selection may be necessary; this must be done fairly, in order to use something painted by every child, yet sensibly, with an eye on the end product. The background paper should be laid flat on the floor and the cut-out figures moved about on it until the whole is artistically, as well as geographically, satisfying. Much social training goes into such a piece of work at this stage, but as a rule one gets true co-operation from the children. As much as is possible of their work is used, and is finally stuck down by groups of four to six children at a time, working in relays. It goes without saying that such a panel, on such a vivid, colourful subject, could be equally (or even more) effective in mosaic or collage, and in its turn could be followed by three-dimensional work of all kinds, and by drama, music, movement, English and science (cooking by primitive means, for an example).

History can be treated in the same way. To make history

live for young children, the imagination must be tickled. A medieval fair, the seige of a castle, a Roman triumph or the Great Fire of London would each lend itself to the same sort of treatment as the African Market, enabling the children to 'see into the heart of a thing', as Thomas Hardy said, 'achieving realism in reproduction by pursuing it by means of the imagination'.

An imaginative teacher can also get much individual art work out of history or geography by asking for 'close-up' pictures—of an African drumming, with his drum between his knees, or of an old Moslem chief in his white cap, sitting before his hut; of an old woman rescuing a beloved possession from the fire, or of a family taking refuge in a boat on the Thames with the flaming sky behind. Again, I am tempted to stress how dependent upon each other are all the Arts, and history could be perfectly well served by orchestrating 'London's burning', with percussion and pitched-percussion instruments, the children moving to the orchestration and interpolating bits of drama and poems which they have written.

Mathematics can be more difficult to link with art than any other subject, and I, personally, would not force the link unnaturally. On the other hand, natural science lends itself wonderfully to art work, especially when good magnifying lenses are available. Music has to be handled with care because, although much music is pictorial, and many folk songs and rhymes certainly make marvellous subjects for pictures, I do not believe small children enjoy or understand abstract art. I should never ask children in a Primary School to 'paint' Paganini's Violin Concerto, though I might use Saint-Saens' *Swan* or Dvorak's *Carnival* to enhance imagination, when the visual stimulus has already been given in some form other than the music.

Fig. 25 is a 14th-century cottage, painted by a girl of nine, and Fig. 24 a detail from a flower panel, in which natural science, art and music were linked through Vivaldi's *Four Seasons* suite.

12 Art as 'Spiritual Education'

I must now return to the Infant School and the question of illustrating stories, whatever their origin. In doing so, I will also deal with the one subject I left out so conspicuously before, namely, Religious Education, the subject which lies perhaps closest of all to the world of art, by reason of its nature and the precedents provided by great artists of all ages.

Suggestions for illustrating stories

I have, I think, seen more 'failures' from children who, after hearing a story, have been asked to 'do a picture of it', than in any other situation. The reason is not really very far to seek. A story is a *sequence of events,* and the details of each one, as it occurs in the framework of the tale, tend to wipe out those of the previous one. The visual images the child receives are only fleeting, and are relatively unimportant compared with the pattern of content in the story. Faced with the difficult problem of selecting one incident or one situation from the story, the child is overwhelmed in any case; but to recall details which would help him to make a picture is well-nigh impossible.

Under these circumstances, the child sometimes attempts to retell the story by putting down haphazardly, on paper, objects which are really no more than symbols of the sequence of situations; so that Red Riding Hood and Grandmother, the Wolf and the Woodman, basket, butter, flowers, trees and everything else, are thrown in without any relationship at all to

each other spatially, and without any relation whatsoever to any particular moment in the tale. Less able children seem unable to select even the symbols of the situations involved, and, in an agony of frustration, paint some tiny object right in the middle of their sheet of paper, often filling the space around it with unrelated masses and squiggles until, as if by accident, the unsatisfying attempt they began with is covered over and the 'picture' discarded.

Once a teacher has understood the children's difficulty, it is very easy to help them. Most children above the age of five years have some facility in drawing figures, but the difficulty often lies in getting them to draw the figures large enough for any significant detail to be added. So, if the story has been of Little Red Riding Hood, let us make sure that, however crude the child's picture of a little girl may be, it is at least big enough to show **(a)** that she is wearing red (the paint must be clean enough, too!) and **(b)** what she is doing. Now **(b)** must depend upon what particular little bit of the story it is that is being tackled, but just to ask what Little Red Riding Hood is likely to be doing is enough to help the child select. 'Talking to the wolf in the wood', may be the answer given. 'Very well,' says the teacher, 'now look at your piece of paper. We want to see Red Riding Hood and the Wolf. Make her head nearly touch the top of the paper, and her feet nearly touch the bottom. Leave room for the wolf at one side.' When this has been done, trees, flowers, grass, Red Riding Hood's basket, etc., can be added. Details extraneous to this incident are not included; for one thing, the child's attention has been fixed, and for another, the paper is already filled with the principal objects and does not require more.

Some problems

Whatever the content of the story, this sort of pin-pointing is valuable. Folk tales are eminently paintable, and stories from history, geography, and 'Scripture' all come out well, under the same sort of treatment. So do nursery rhymes—though here we come to another common cause of failure. Most children

see books of nursery rhymes which are already illustrated by an adult, so that Little Miss Muffet and Simple Simon already have an image attached to them, supplied, not by the child's own imagination, but by some other artist. The poor child is then in the difficult position of trying to make his picture look like the image he has already been given, with the result that he generally fails to satisfy himself at all and gives up in helpless despair, or else he is getting along very nicely creating a new image of his own, when some other five-year-old comes up and says disparagingly, 'That's not Miss Muffet. She's got a pink frock,' and confusion sets in again. The same applies to 'doing pictures' of such classics as Little Black Sambo, where the original illustrations are absolutely part and parcel of the story. On the other hand, one person's idea of 'the little old man' of so many folk tales, or of a hobyah, a fairy, an elf, or a talking crane or what-have-you, is as good as another's. In suggesting ideas from stories to be painted, discrimination on the teacher's part is as valuable as it is in any other branch of the curriculum. Some previous thought about which stories are useful in this way, and which are not, is really essential.

Art and Religious Education

If I can now go back and take up the question of imagination, it will perhaps make it easier for me to elucidate a difficult point with regard to Religious Education. If I were to ask ten adults to take a piece of paper and draw a 'sprostawogger', I would obviously get ten different things; but if this object appeared in a story, from which emerged the fact that it had four wheels, could move along a road and lift things up and down, then the ten pictures would be much more alike. (Actually this was the word invented on the spur of the moment by a young man in answer to an African's demand to know what the enormous yellow contraptions used in road-building were called.) So, therefore, within the bounds set by the context, each person's own image is valid and right. If there are too many limits set by the context, then the image becomes completely controlled, and imagination turns into representation. In the case of Little

Black Sambo, all the children can do is to *reproduce* the original images; in a folk tale each can produce his own image, helped by the context of the story.

In stories from the New Testament, the main protagonist, Jesus, constantly appears, together with half a dozen or so other recognisable characters. The object of the stories is to introduce children to these characters, but, as nobody knows what they did look like, it is absolutely essential that each child should form his own image. For this reason art work by the children themselves is invaluable, and cheap illustrations by adults dangerous and disastrous, especially as many of them portray Christ as a poor, pale, weakly-sentimental man, clothed in outlandish fancy dress, and performing deeds utterly beyond an Infant's comprehension. If there is any point in telling these stories at all, it surely must be that He was much, much more than a persecuted historical character who once lived half the world away. Nevertheless, discrimination is again needed in choosing which stories can be understood well enough for a picture to be tackled, and which not. In the Junior School, the children can, and will, tackle almost any of the well-known stories.

The Old Testament, on the other hand, is full of incidents exciting to Infants, though not necessarily of great value spiritually. Fig. 26 is from a book of 'Jonah and the Whale', made by five-year-old children. Fig. 27 is a six-year-old's picture of Elijah being fed by the ravens. Fig. 30 is 'Christ Mocked', by a girl of nine, part of a frieze in which all the other pictures were co-operative efforts.

For older children, the Old Testament is an artist's paradise. Constant retelling has made the stories utterly familiar, but time and reportage have reduced them all to their bare essentials. What is left comprises the skeleton of events, upon which a fertile imagination can go to work without restriction of detail imposed by anybody else. Individual pictures (Fig. 28 is 'Moses coming down the mountain', by a boy of nine), co-operative work (Fig. 29 is 'Palm Sunday', with the age range four to eleven years, fully represented), work in individual books or in group books or class books, are all exciting

and within the children's scope. I have several books which were made simply by breaking up a well-known story into clear-cut incidents, and, after the children had drawn the pictures, I added captions to enable them to read the story again. In the Junior School the children themselves wrote the story accompanying the pictures, as in a book about Joseph and his brothers, the whole of which was brilliantly painted in coloured ink.

Among my greatest treasures are several books of illustrated psalms, made in the same way; one in particular, Psalm 104, from which my last illustration is taken (Fig. 31), is remarkable. In this, the subject, the language and the pictures are so much akin that one almost involuntarily substitutes 'Spiritual Education' for 'Religious Education', recognising in it the perfect integration of all these things of the spirit. Any pre-occupation with 'pictures' or 'paintings', topics or techniques, media or methods, play or purpose, is forgotten as one turns the pages, for, in catching the very essence of the subject in the very essence of the medium chosen, and by illuminating each page with the untrammelled confidence of childhood, the fifteen children who created it produced something truly worthy of the great name of Art.